LETTERING ART IN MODERN USE
STUDENT EDITION

RAYMOND A. BALLINGER

LETTERING ART IN MODERN USE
STUDENT EDITION

REINHOLD PUBLISHING CORPORATION

NEW YORK

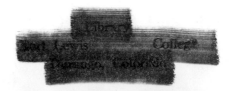

MLB
LBB

TO MY MOTHER, MARY LIZZIE BALLINGER
AND TO MY WIFE, LOUISE BOWEN BALLINGER

THE DECORATIVE KEY IS FROM THE HAND OF MY FRIEND ARTHUR WILLIAMS

CONTENTS

The preparation of a collection of any art form becomes at once a difficult and a thrilling experience. The lettering in this book was gathered over a considerable period of time for the inspiration and instruction of students in my classes in lettering, and most of it appeared in a larger edition, published in 1952 and reprinted in 1956. I gratefully acknowledge the consent of many individuals and organizations for the inclusion of their material; it has been properly credited on the page on which it is presented. Dean Edward Warwick of the Philadelphia Museum College of Art, Mr. Arthur Williams, Mr. Dan Moerder, Mr. Sol Mednick and Mr. William Frampton must be especially thanked for their interest and assistance. So must the editor, Mr. William W. Atkin, for his work on the first two editions and my wife, Louise Bowen Ballinger, for her constant help and encouragement. Students and others may be appreciative of the suggestion of Mr. Jean Koefoed, the editor of this edition, that a condensed and less expensive volume would be a welcome addition to a student's library of the graphic arts.

R.A.B.

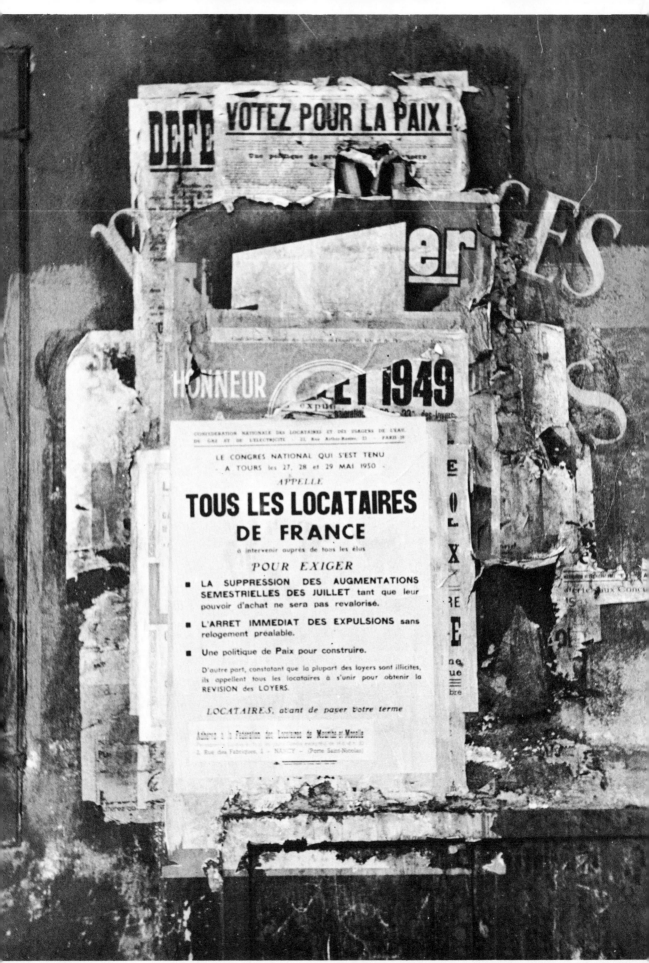

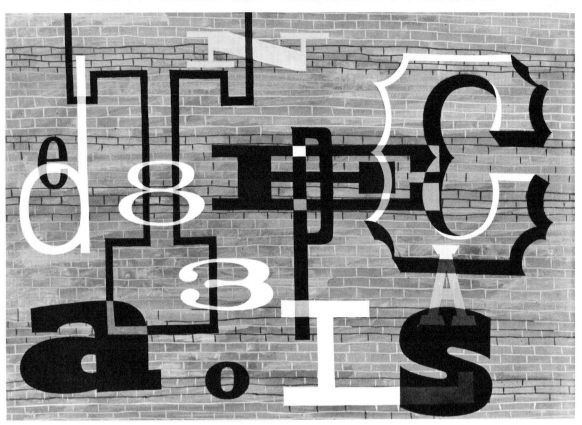

Experimental design with letters by Thomas Vroman.

The letters of our alphabet are constantly around us. They may be so obvious in our everyday lives that we become almost oblivious to them. However, the perceptive person will be intrigued by and find inspiration for letter designs even in such things as the fragments on an old posting board photographed in Nancy, France. The composition of letters shown above may have been inspired by such a find or, possibly, by individual letter forms made to be used on signs or architecture (below).

Although we may be unaware of it, we are much affected by letters in everyday use. We may experience unusual pleasure in reading a book and may hardly be conscious that the type and its arrangement have been responsible for some of that

9

HAMILTON

ANDORRA TEXT

ANDORRA COVER

HAMILTON TEXT

HAMILTON COVER

VICTORIAN TEXT

VICTORIAN COVER

Letters designed by the author for a paper sample
book for W. C. Hamilton & Sons, Miquon, Pennsylvania.

pleasure. We can be soothed, satisfied, amused, alarmed — even angered — by the
subtle qualities of letters. We enjoy beautiful letters or initials on precious objects or
respond to fine lettering on a poster or a sign. We may be transported from our every-
day world into realms of make-believe by the subtlety of title letters for a motion pic-
ture or a TV program. Letters, indeed, are all around us. It is important that artists
and designers appreciate fine letter forms and become proficient in their use.

Men did not always use letters. There are many theories about the beginnings of
our letters with, doubtless, large elements of truth in all of them. Cave men, the Egyp-
tians, the Phoenicians, the ancient Greeks and the Romans, all exerted an influence
upon the beginnings of our alphabet. We can be certain that for centuries the graphic

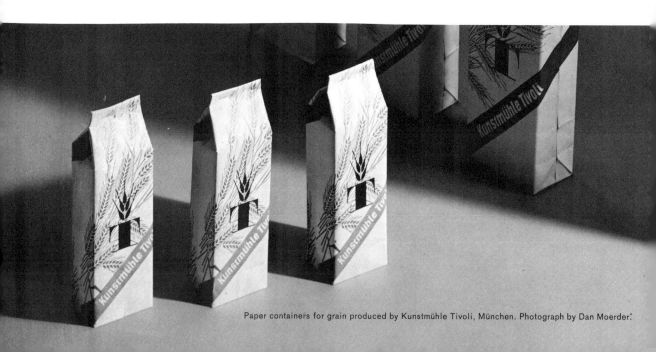

Paper containers for grain produced by Kunstmühle Tivoli, München. Photograph by Dan Moerder.

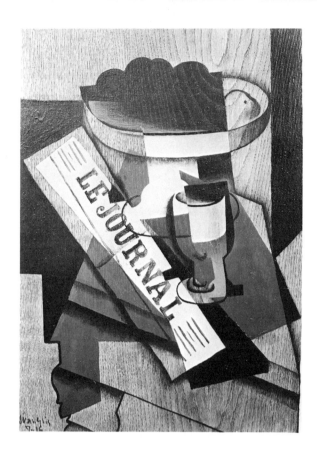

An example of lettering as an integral part of a painting. By Juan Gris, 1916, from the collection of The Museum of Modern Art, New York..

records of early times were "pictures." Man's unending search for more efficient ways of doing things changed these pictures to symbols—letters. His body, his food, his home, his transportation became the basis of his alphabet because they were important to him. History records the progressive stages. OX: Phoenician, aleph; Greek, alpha; Roman, A. HOUSE: Phoenician, beth; Greek, beta; Roman, B. (Here, incidentally, is the derivation of our word "alphabet," from the two Greek words "Alpha" and "Beta.") Thus we see that the "picture" quality of the letter is entertaining and significant. The letter artist contributes, through the imaginative presentation of his letter, a **picture** to the mind of the reader. Letters written or drawn to convey such a picture become thrilling, indeed.

Letters cut in wood for display purposes. Courtesy of Argus, Incorporated.

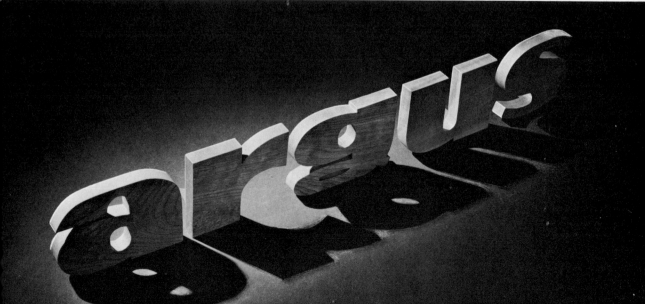

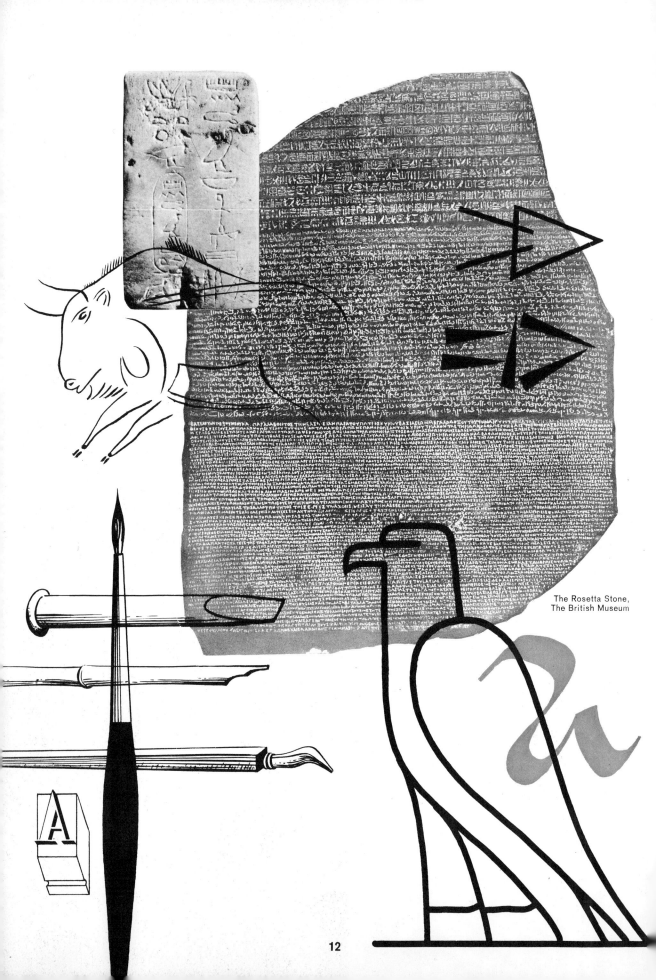

The Rosetta Stone,
The British Museum

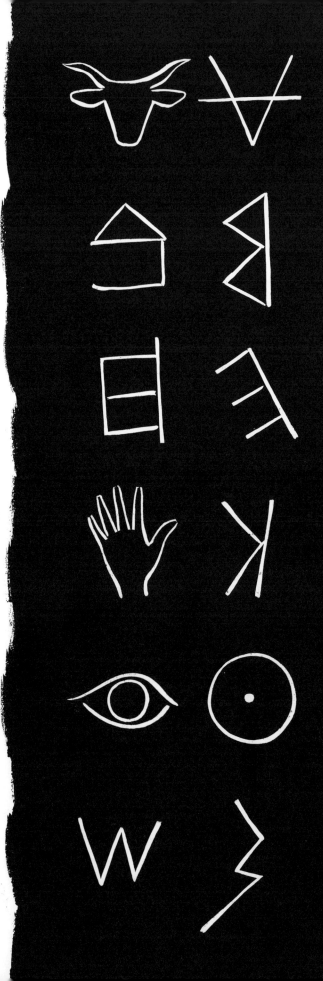

Some of the tools and some of the steps in the development of our alphabet are shown on the page to the left. Our letters have developed over a long period of time. The process was tedious, and it was consistent with the progress of the period and the materials available for their application. The illustration shown here will help to explain, in a very simple manner, how men sought to speed their communication by developing, first, pictorial forms and, later, symbols to express their ideas. Today we think of our letters as expressing sounds rather than things. Early symbols were naturally very simple—contemporary letter forms have developed into incredible variety and for myriad applications. Beyond its power to convey a message, a letter can, by its very styling, create an atmosphere and a mood. Men's earliest efforts were naturally concerned only with creating forms which could be read and understood by other men.

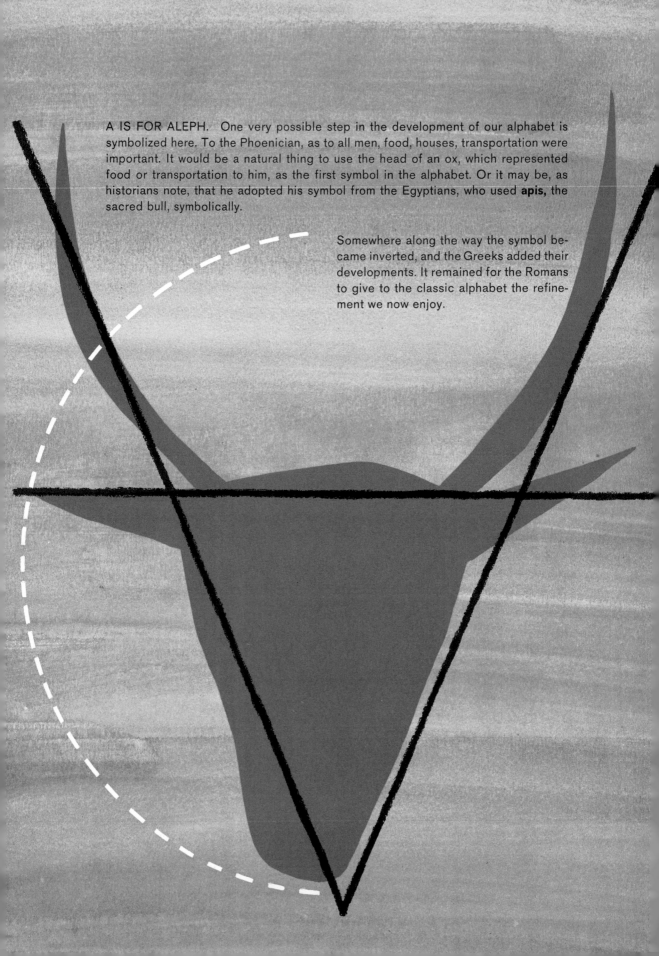

A IS FOR ALEPH. One very possible step in the development of our alphabet is symbolized here. To the Phoenician, as to all men, food, houses, transportation were important. It would be a natural thing to use the head of an ox, which represented food or transportation to him, as the first symbol in the alphabet. Or it may be, as historians note, that he adopted his symbol from the Egyptians, who used **apis,** the sacred bull, symbolically.

Somewhere along the way the symbol became inverted, and the Greeks added their developments. It remained for the Romans to give to the classic alphabet the refinement we now enjoy.

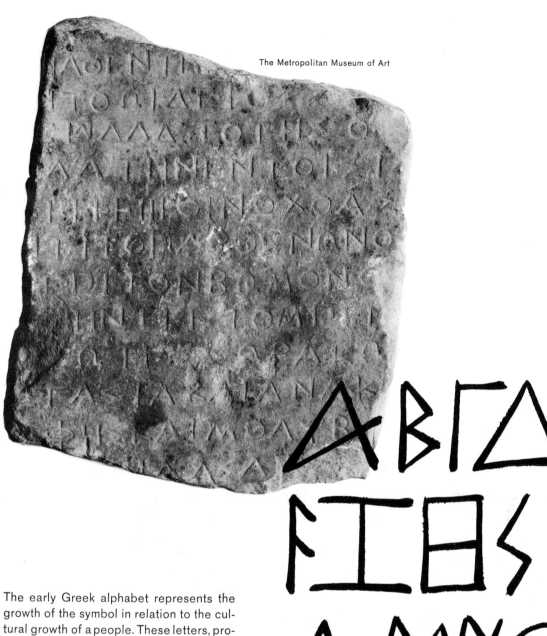

The early Greek alphabet represents the growth of the symbol in relation to the cultural growth of a people. These letters, produced with a stylus in wax, did not develop the thick and thin characteristics of later Roman forms. The Greek inscription of the 4th century, above, is quite suggestive of many contemporary forms—namely, letter forms commonly called the "Modern Gothics" and type faces such as Futura and Standard.

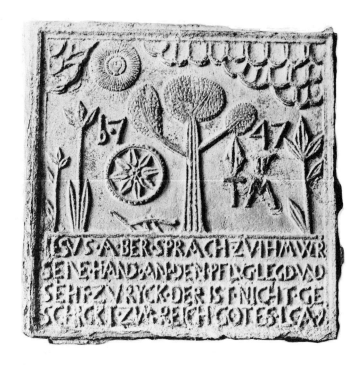

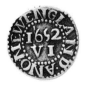

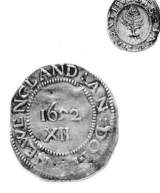

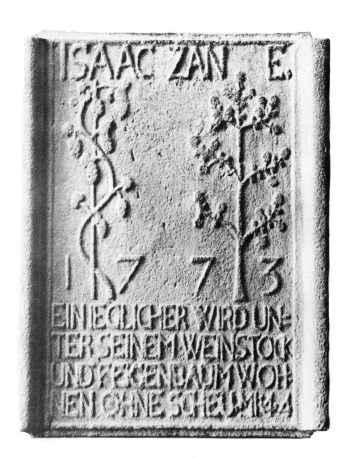

The unsophisticated character of letters on old coins and old stove plates have much in common with earlier letter forms. The coins are from the collections of the Metropolitan Museum of Art, New York, and the stove plates are from the collections of the Bucks County Historical Society, Doylestown, Pennsylvania.

ROMAN

One begins to analyze the Roman letter in something of a spirit of awe—not unlike what he feels in handling a precious gem or inspecting a perfect object of nature. Here, in the hands of the artist, is an alphabet of such perfection that he may either use it as he finds it or use it as an inspiration leading him into new realms of lettering art. He must learn to respect its basic rightness, its elegant proportions, and its pleasant subtleties, whatever his purpose may be. This response is not always immediate, any more than is the response to what is finest, but perhaps unfamiliar, in music or art or architecture. The full virtue of the Roman letter must be absorbed, for the basic rules of its formation are relatively simple and this simplicity is what must be sought out. The thick and thin stroke structure has been more confounding to young designers than anything else about the Roman alphabet. On the following page is the immediate remedy for this difficulty: The placement of strokes in the letter is actually as normal as the anatomy of the human body—and infinitely easier to master. Having mastered some detail as to the proportions of the strokes and the proportions of the letters themselves, the designer is well on his way to a rich experience in letter design.

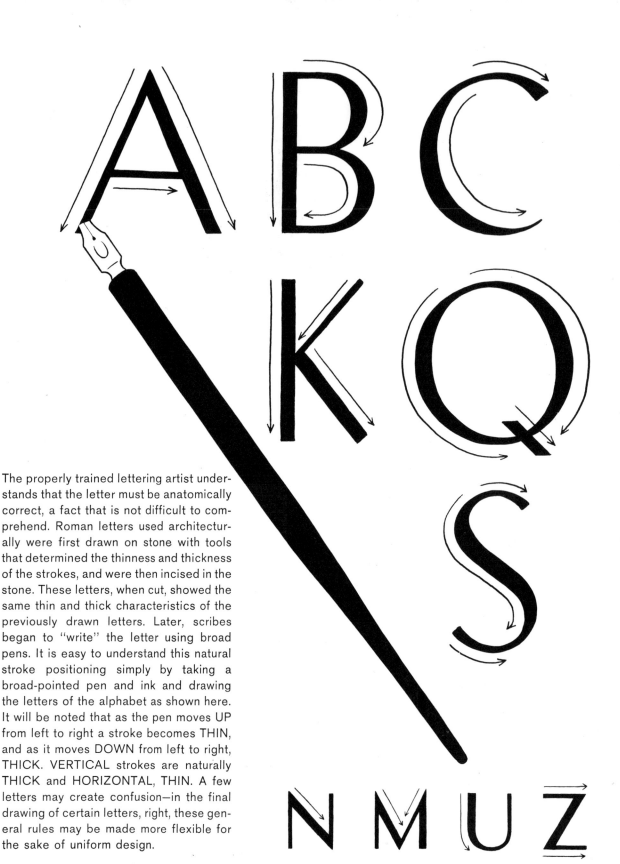

The properly trained lettering artist understands that the letter must be anatomically correct, a fact that is not difficult to comprehend. Roman letters used architecturally were first drawn on stone with tools that determined the thinness and thickness of the strokes, and were then incised in the stone. These letters, when cut, showed the same thin and thick characteristics of the previously drawn letters. Later, scribes began to "write" the letter using broad pens. It is easy to understand this natural stroke positioning simply by taking a broad-pointed pen and ink and drawing the letters of the alphabet as shown here. It will be noted that as the pen moves UP from left to right a stroke becomes THIN, and as it moves DOWN from left to right, THICK. VERTICAL strokes are naturally THICK and HORIZONTAL, THIN. A few letters may create confusion—in the final drawing of certain letters, right, these general rules may be made more flexible for the sake of uniform design.

Experience in using a broad pen will reveal a consistent placement of stroke thicknesses. As the pen moves UP from left to right as a stroke becomes THICK, and as it moves DOWN from left to right, THICK. VERTICAL strokes are naturally THICK and HORIZONTAL, THIN. In the final drawing of certain letters, above, these general rules may be liberated for the sake of uniform design.

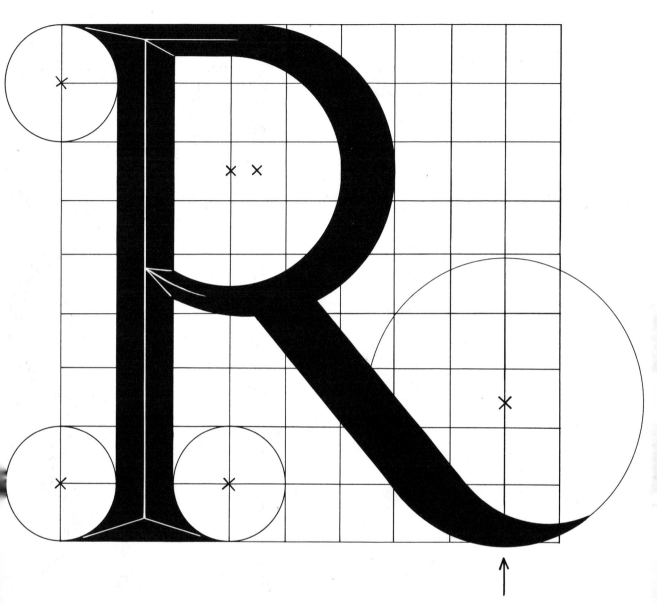

The Roman letter is the ultimate expression of ease and grace, even when, as has so often been the case, it is incised in stone. The chart method of showing a typical letter will, therefore, appear very stiff. It will serve, nevertheless, as a basis for showing the proportions of both the letter and the strokes. A complete alphabet showing the construction of each letter in the alphabet appears on pages 20 and 21. A few comments are pertinent. Variations of proportion exist, but generally it will be found that the thick strokes of a letter will be about one-ninth the height of the letter. The thin strokes will be about one-half this thickness. The letter shown is based on these proportions. The **serifs,** or finishes of the strokes of the letters, were so important as a matter of cleaning up the stroke endings that they became a natural part of the letter form. The classic letter has come to us from about 100 A.D.

A few letters which touch top and bottom guide lines in a point or a circle may have to be drawn beyond the guide at these places, lest they appear small. Such letters are A, V, M, N, W and C, G, O, Q, U.

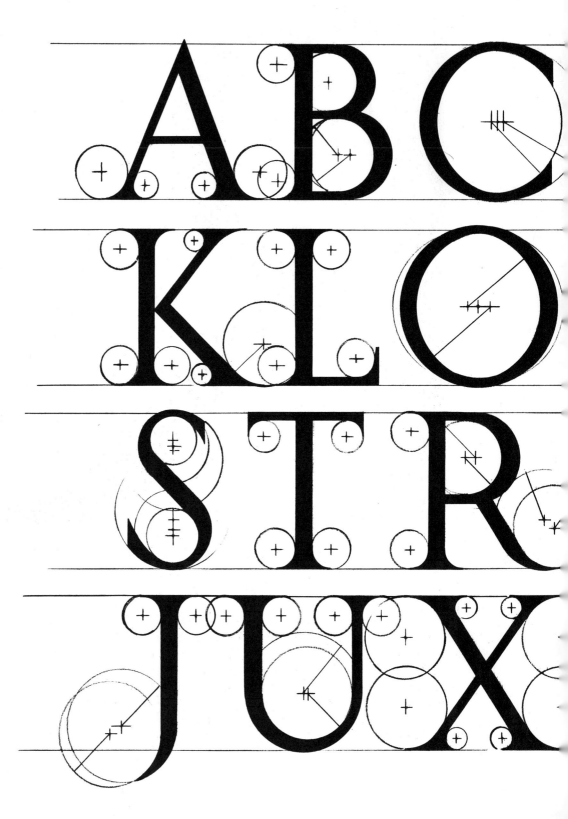

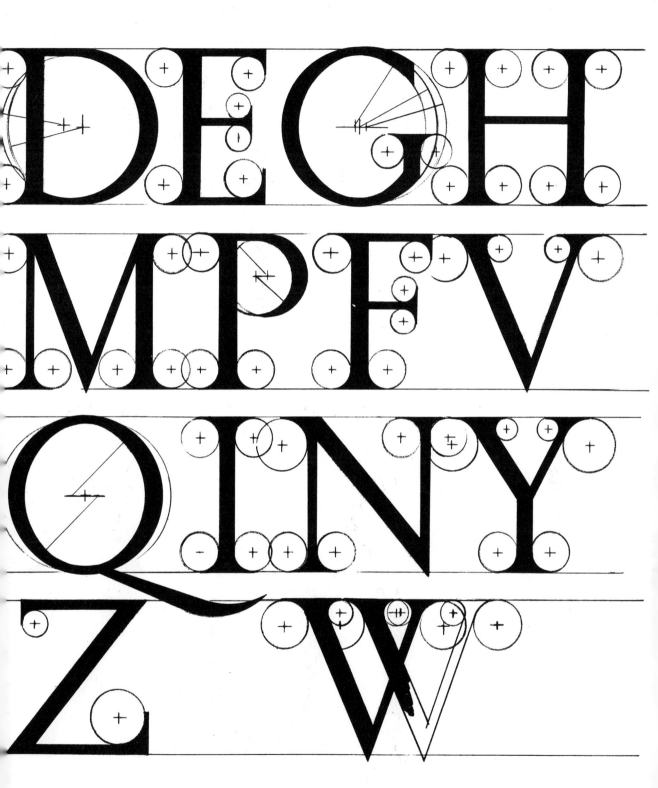

This Roman alphabet has been very tightly drawn as a model for the construction of this letter form. The proper attachments of the serifs and their proportionate relations to each specific letter can be studied here. Roman letters become most elegant when the rules of construction are observed and when the letters are more freely drawn, as in the alphabet on the following two pages.

ABC
KLO
STR
JUX

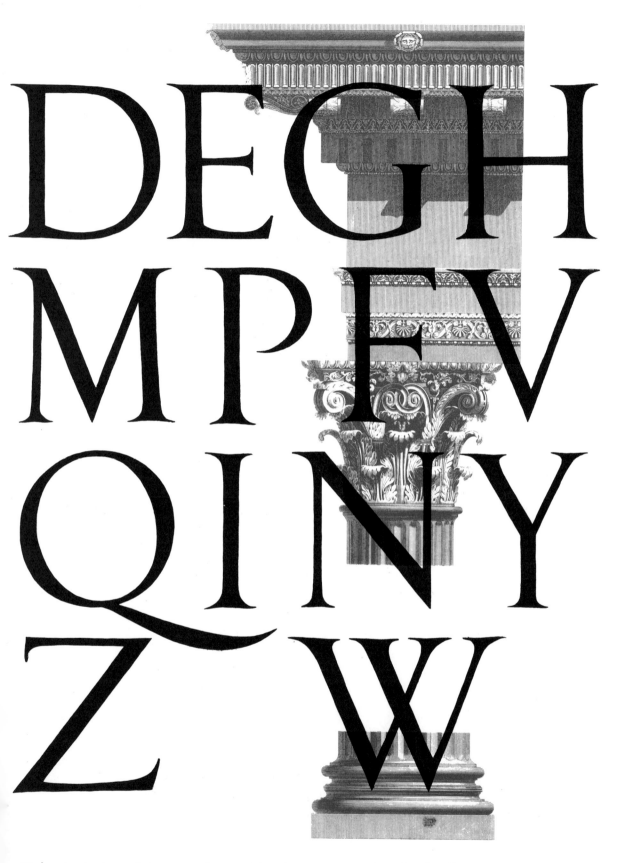

DECHGH
MPEV
QINY
ZW

These freely drawn letters may be considered as representative of a fine Roman alphabet. Though the letters J, U, and W were not in the early Roman alphabets, they are drawn here in the spirit of the other forms.

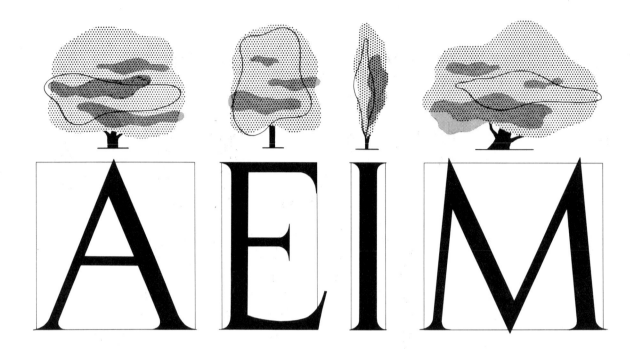

The anatomy of the letter is important; the proportion is of equal importance. If we create a mental "picture" of a wooded area we realize nature's sense of relationship and harmony. We see that some trees are tall and slender, others are more round, and still others are very wide in proportion to their height. The simple diagrams of trees at the top of this page may help to give graphic accentuation to this very important principle. Some letters are of a pleasant proportion when relatively square, as in the A above. Others must be wider than high; some much narrower. It is possible to classify these proportions generally in the following manner: Square—A, D, G, H, N, O, Q, U, V, X, Y, Z. Narrow—B, E, F, K, L, P, R, S, T. Thin—I, J. Wide—M, W.

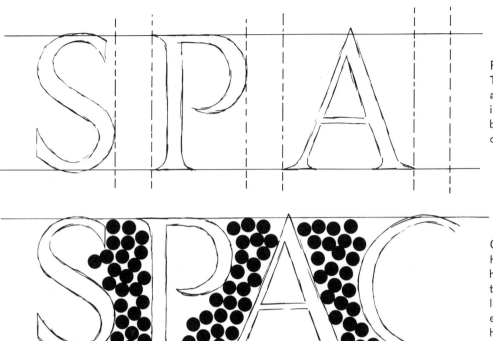

The spacing of letters within a word is almost as important as the design of the letters themselves. A stumbling block to many, spacing may easily be mastered by the careful and observant designer. It is important to remember that spacing is "of the eye." Fine spacing cannot be a measured or mechanical procedure. Rather, one must try to visualize the same **area** between each of the letters in a word. These areas will not, of course, be the same shape, for they must fit the contours of each letter. Creating a mental image of a word with the same number of pellets between each of the letters (as suggested in the sketch above) helps to create a pleasant optical sensation of space. Good "color" in a word is the result of fine spacing.

SPACING

SPACING

POOR
This is an obvious example of poor spacing. The spaces between letters are too wide in some cases and too narrow in others, producing an unfortunate result.

GOOD
An even flow of the areas between letters results in a restful and pleasing word. Good legibility and good color have been achieved.

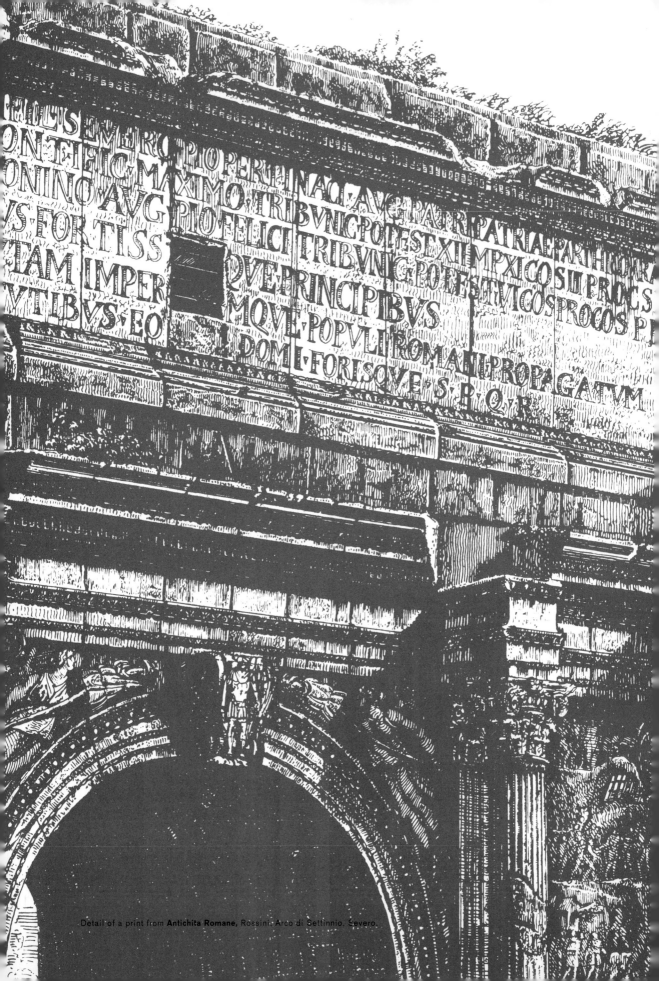

Detail of a print from **Antichita Romane**, Rossini. Arco di Settinnio. Severo.

Fragment of a Roman inscription. The Metropolitan Museum of Art.

Sixth-century manuscript letters from the Library of the Vatican, Rome, as found in **Paléographie,** by J. B. Silvestre. The Free Library of Philadelphia.

Up to this point our study of the Roman letter has been concerned with the large or capital letters. The importance of the Roman capital letter and its use in monumental inscriptions is well known. But the letter has significance, too, in the beginning of our minuscule or lower-case forms. The increasing need for books, documents, and proclamations made necessary a faster form of writing letters, and this need had its influence upon letter forms. Slowly the letters emerged into the lower-case letter forms we know today.

Seventh-century manuscript letters from the Libary of the King, Paris, as found in **Paléographie,** by J. B. Silvestre. The Free Library of Philadelphia.

27

ROMAN

The earliest written forms of the Roman letter were accomplished with a quill pen and were copies of letters which had been incised in stone. As indicated by the word at the left, they were less precise than the incised forms and showed the effort to write faster.

A B C D E F G h I J K L m

As time passed the need for writing increased. Letter forms varied in spirit with the time and with the people who executed them. This alphabet is typical of the Roman Uncials of about the 5th century and begins to show characteristics of our lower-case letters. This and the alphabet just below will be found useful for exercises in pen-drawn letters.

A B C D E F G H I J K

abc de fghi Jklmon

An even faster-moving pen letter is shown here in what is known as a Chancery Cursive form typical of about the 15th century. The beginnings of handwriting are evident here and also in the italicized letter. The alphabet includes the majuscule (capital) and minuscule (small or lower-case) letters.

Caroling a Courtly Christmas

This example of contemporary lettering is definitely related to the forms illustrated above and to other written letter forms in the long history of writing. They were prepared by Marley Hodgson for Yardley of London. Art Director, Leon Karp. Agency, N. W. Ayer & Son, Inc.

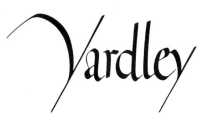

Yardley

The few letters at the right indicate, on the other hand, how carefully the characteristics of the incised letter have carried over to contemporary type faces. These are Goudy Oldstyle 48 point capitals; they could easily be the models for incised forms.

ABCDEFG

NOPQRSTUVWXYZ

ℓMNOPQRSTUVWYZ

p Qqr tu vαwyz

A delightful assembly of letters in the spirit of others on this page, prepared by William G. White after only a few lessons in the basics of lettering.

The development of written forms brought about the formalization of our lower-case and italic forms. Type itself came into use in the 15th and 16th centuries, and it is not difficult, therefore, to understand the close relationship between the written and type forms. The first line to the right is the lower-case of the Goudy Oldstyle shown above, and the second line shows the italics of the same type family. Both are 48 pt.

abcdefghijk

ABCdefghijk

Aabcd
efghijk
lmnop
qrstu
vwxyz

This is a representative lower-case alphabet in classic spirit. The capital A is shown to suggest relative height.

THE First Psalm Book was printed by the great John Carter 1692-1766

[This page is set in 72-point Caslon Old Face.]

The importance of the Roman letter in the development of type is evidenced in this handsome page of Caslon type. It is reproduced from an old Caslon Specimen Book by permission of the Caslon Letter Foundry, London, England.

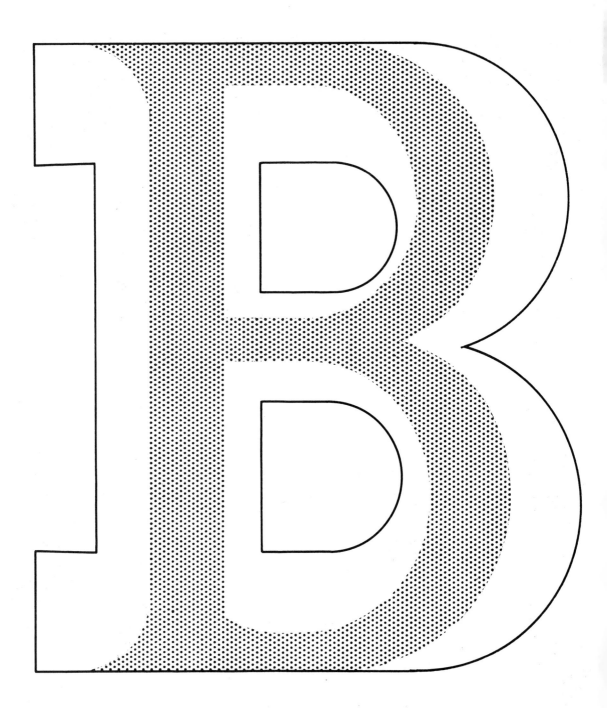

The Roman letter has proved to be a solid basis for the design of a modern letter or type face. On preceding pages the correct proportions of the classic letter were given. The diagram shows that the placement and relation of the thick and thin strokes must be just as rational in the modified letter. Thick strokes must remain consistently thick; thin strokes remain thin. The proportions of these strokes may, of course, change. Serifs may also change, but their character and proportions become consistent with the general character of the new letter. This structural knowledge and its application has given us a heritage of many handsome letters and type forms.

This is a greatly enlarged letter in the spirit of the contemporary type face known as Stymie. The letter has been executed in relation to the outline drawn on the opposite page and shows the consistency of thin and thick stroke structure explained there. The portion of the alphabet printed below is set in Stymie Extra Bold.

ABCDEFGHIJKLMNOPQRST

£238

Memoir

DINGLE

DONCASTER

LECTURE

160

R

Old type specimen books are rich sources of inspiration for lettering. These samples show the great variety possible in letters based on the thick and thin stroke principle. Type designers have been much influenced by old type forms, as evidenced in many type faces in contemporary use.

FRENCH ACCENT IN OHIO

Extremes in stroke width are exemplified in these letters for **Town & Country** maga-
zine by Paul Beers, 1949. Art Director: Suren Ermoyan.

KNOBS
State House

R

S

The first purpose of serifs, as noted on another page, was as a method of cleaning up and making more graceful the stroke endings of a letter. These forms contributed a pleasant finish to the letter and have been adopted in numerous ways. Whatever the letter form, the serif must be complementary and consistent with the letter itself. All letters do not have serifs—there are the simple and elegant sans-serif forms, information about and construction of which will be found on other pages of this book. These, too, are widely used and simply carry out the idea of our very first letter forms, which had not yet developed the serif endings.

ALBERTINA

die klassiker

A

des kubismus

in frankreich

AUSSTELLUNG FRÜHJAHR 1950
geöffnet: Montag, Dienstag, Donnerstag von 10-13,
Mittwoch, Freitag, Samstag 10-18 und Sonntag 10-12

K

Simplified classic letters, in both capitals and lower-case forms, have been used on this handsome poster designed by Karl Kohler, Vienna, in conjunction with a lithograph by Pablo Picasso.

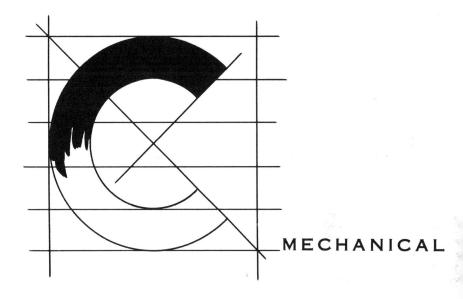

MECHANICAL

The letters in the following section may be appropriately named "Mechanical," although they are commonly called "Modern Gothic"—an unfortunate nomenclature, since they have nothing in common with true Gothic letter forms. We have noted that the Roman letter derives its great beauty from the fact that it is freely drawn. In contrast, the mechanical letter derives its very character from the fact that it is planned with mechanical instruments. Historically we note that its non-serif (sans-serif) form can be attributed to Greek letter forms, which also were without serifs. The mechanical construction does not, however, lessen the possibility of variety in these letters. The designer must remember, only, to plan mechanically, and in so doing he will find no difficulty in solving his individual problems. One fact is pertinent —capital letters such as A, M, N, W are based on angular construction, and the use of rounds in these forms only creates an affectation and lessens simple legibility. Two alphabets are presented on pages 42 and 43, and 45. The first is a simple form based essentially on the square. Its very simplicity makes it a useful letter in functional design, and we find it exemplified in much contemporary architectural lettering and in such important type faces as the Futura type family. The second alphabet is an "alternate" form of mechanical letter and shows the possibility for great variety—in type usage we often refer to these more vertical forms as the "alternate Gothics."

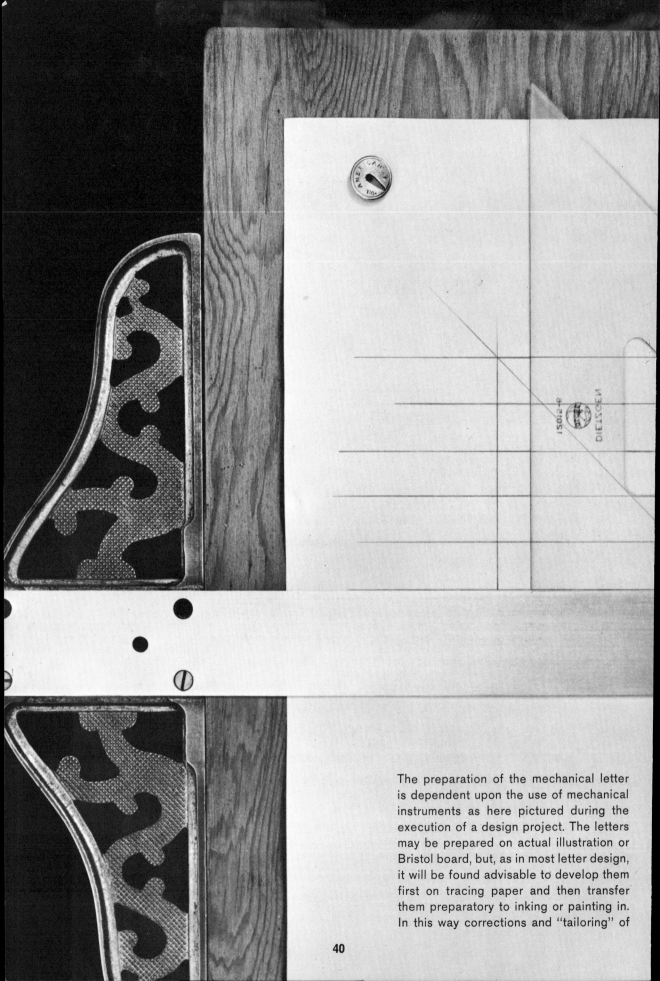

The preparation of the mechanical letter is dependent upon the use of mechanical instruments as here pictured during the execution of a design project. The letters may be prepared on actual illustration or Bristol board, but, as in most letter design, it will be found advisable to develop them first on tracing paper and then transfer them preparatory to inking or painting in. In this way corrections and "tailoring" of

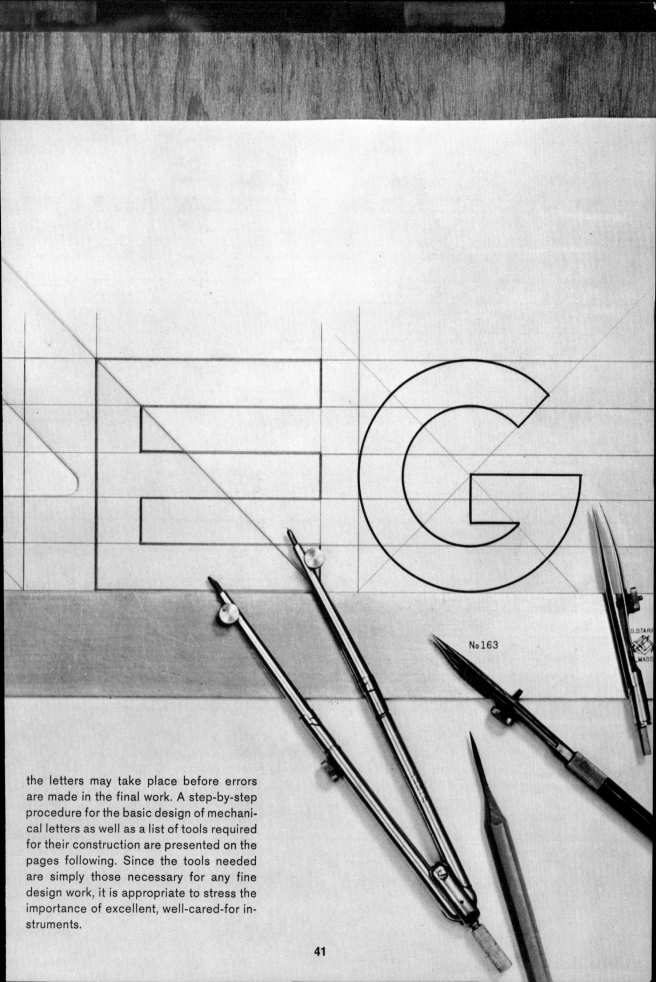

the letters may take place before errors are made in the final work. A step-by-step procedure for the basic design of mechanical letters as well as a list of tools required for their construction are presented on the pages following. Since the tools needed are simply those necessary for any fine design work, it is appropriate to stress the importance of excellent, well-cared-for instruments.

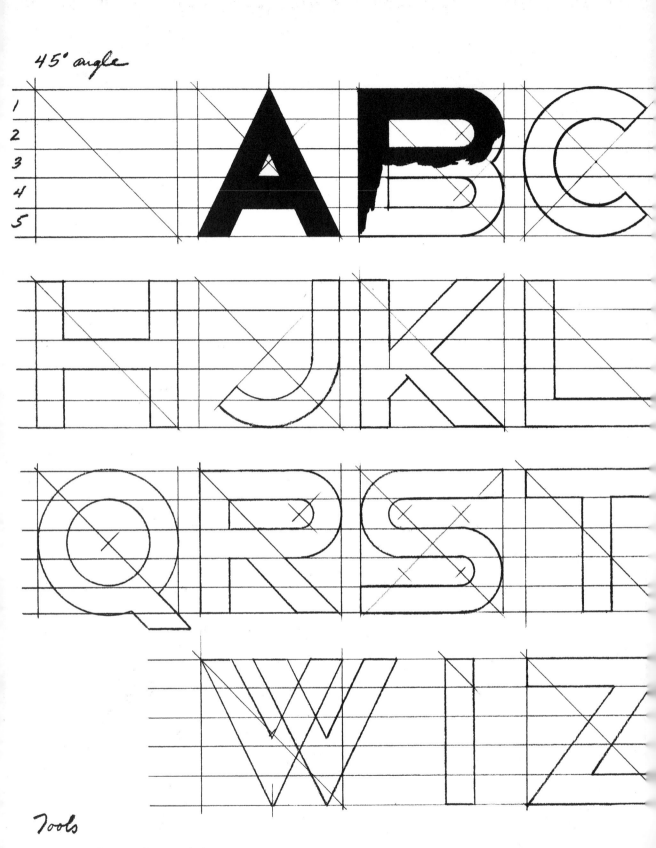

45° angle

1
2
3
4
5

A B C

H I J K L

Q R S T

W Z

Tools

Drawing Board	Thumbtacks	Mechanical Instruments
T Square	HB Pencil	Good Brushes
45° Angle	Erasers	
Tracing Paper	Black Drawing Ink	

42

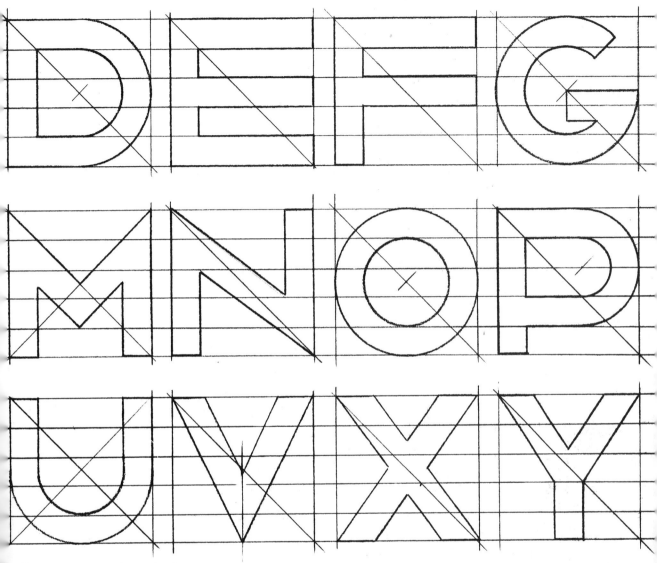

1. Place tracing paper on drawing board and thumbtack (or tape) in proper position. All preliminary preparation of the letters should be done on tracing paper and later transferred to proper paper or board (see Item 6 below) for completion in black and white or color.

2. Plan size and character of letter needed for contemplated design. Draw top and bottom guide lines in pencil, using T square as shown on previous page. If average-weight letter is desired, divide this area into five units as shown above. If heavier letters are required, divide into four units. For thinner letters divide as needed—six, seven, eight units, etc.

3. Use the 45° angle as an automatic guide for measurements. Draw a vertical line for the left edge of a letter. Place the 45° angle at the intersection of this vertical and the top guide line. Where it crosses the bottom guide line, a square for the letter is formed. Where it crosses each unit line, the width of each unit for a vertical stroke is formed.

4. Make certain that all strokes of these letters are the SAME thickness. Plot out the character of the letter, using the T square and the angle constantly. Draw in the outlines of the letter in pencil.

5. As in all letter forms spacing of these letters cannot be mechanical. Consideration for the space between letters in a word must be on an optical basis. See page 25 for instruction about spacing.

6. Transfer the completed tracing of the letters to the paper or board on which they are to be permanently drawn. (A good transfer sheet may be made by smudging on one side of a tracing paper with a soft lead pencil or lead stick. Rub this down lightly with absorbent cotton to prohibit smudging. Place under tracing of letters to be transferred with the smudge side next to board on which transfer is to be made.)

7. Draw in the outlines of the letters with a good ruling pen, using a bevel-edged ruler. Care in the precision of workmanship at this stage will add to the professional appearance of the completed letter.

8. Fill in the body of the letter with a brush of a size convenient to the size of the letters.

9. Possible media: Black drawing ink. Lampblack. For color: Show card or tempera color.

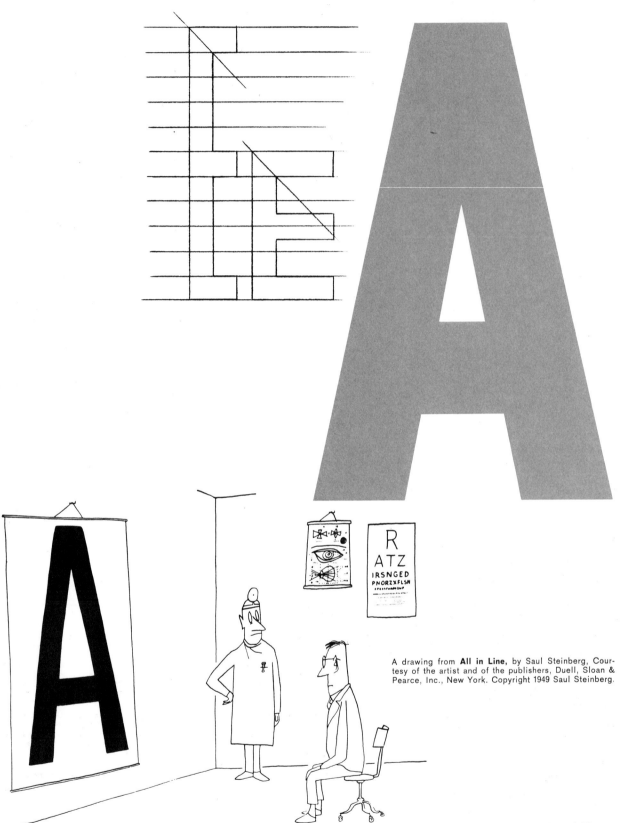

A drawing from **All in Line,** by Saul Steinberg, Courtesy of the artist and of the publishers, Duell, Sloan & Pearce, Inc., New York. Copyright 1949 Saul Steinberg.

The letters on these pages are of the same basic design as those on pages 42 and 43 except that they are narrower and more vertical in form. Letters with thinner strokes are achieved by increasing the number of horizontal units in their construction, as in the tall "E" above. In the alphabet on the opposite page we see the construction lines as well as the finished letters. It will be observed that there are slight variations,

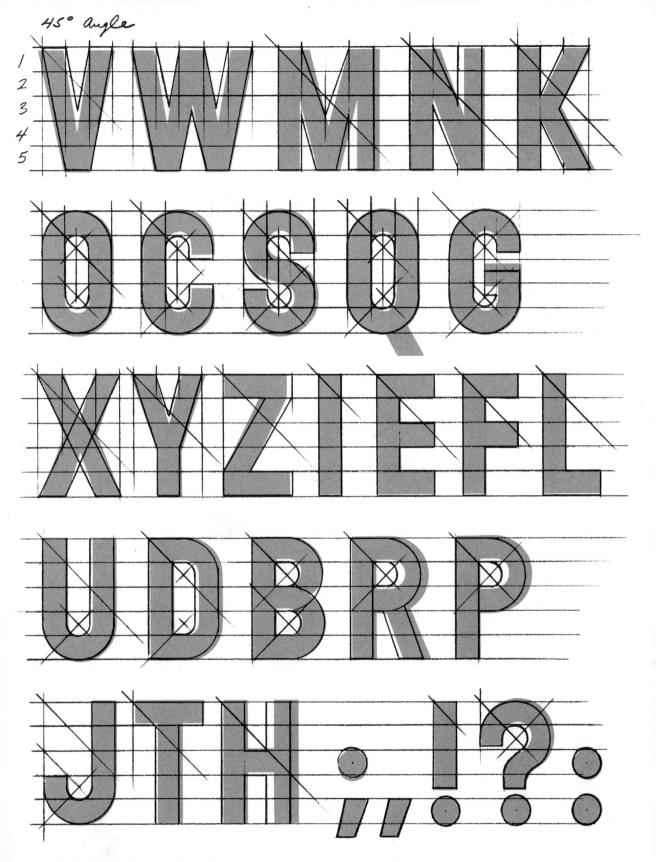

or "tailoring," of some of the letters to prevent certain areas from appearing too black or heavy. When an alphabet is drawn in a taller character it is often spoken of as an "alternate" form, whereas letters which have been noticeably widened are called "extended." The alphabet above was prepared by William Dressler.

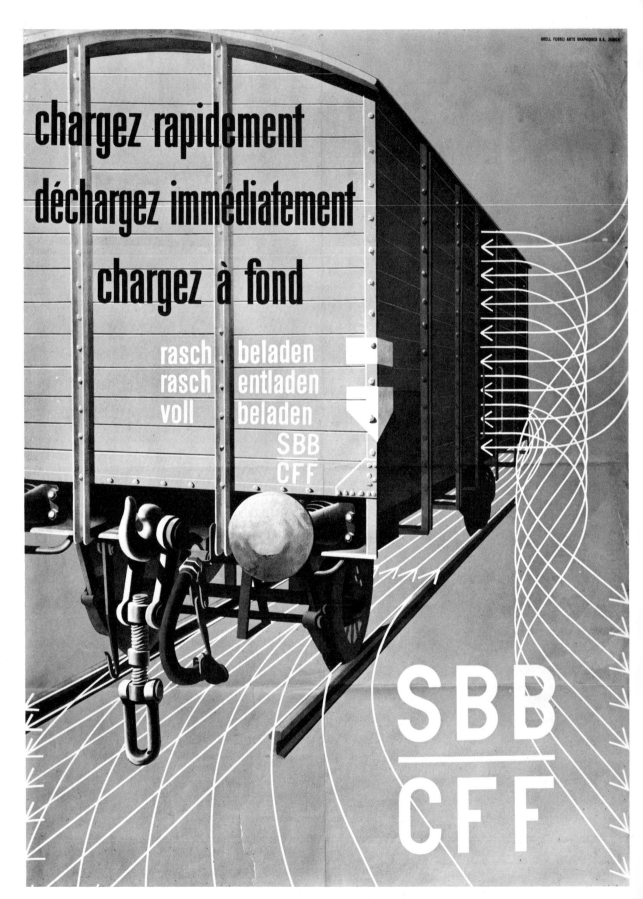

This poster shows the use of both upper-case and lower-case letters of mechanical construction. Designed by Hans Erni for the Swiss Federal Railways and produced by Orell Fussli, Arts Graphique, Zurich.

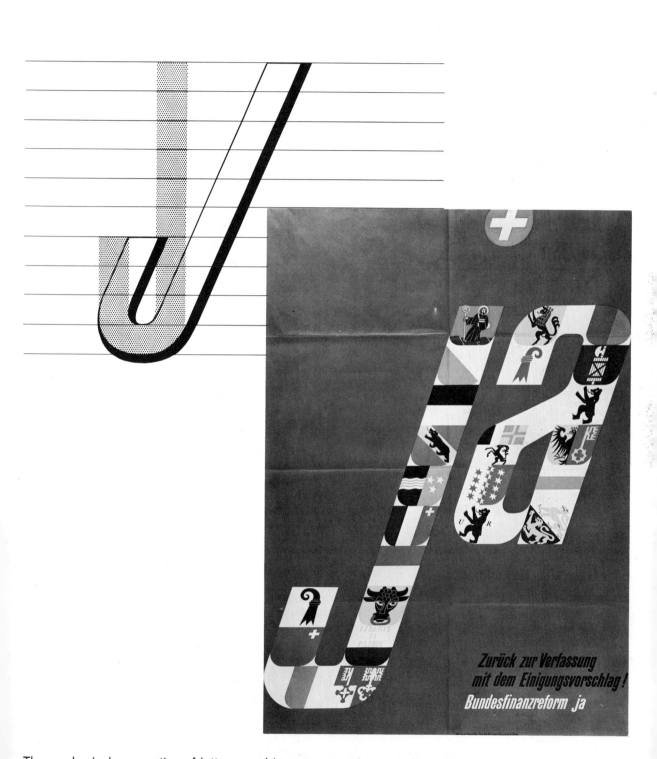

The mechanical preparation of letters need in no way restrict versatility in design. The italicized and shadow forms, above, suggest variations of a creative nature. These possibilities were, themselves, suggested by the poster designed by J. Müller-Brockman and printed by Wolfsberg, Zurich.

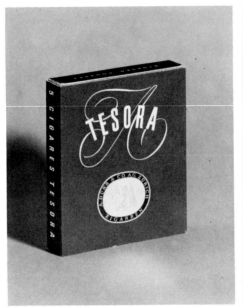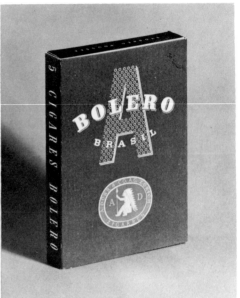

Excellent applications of mechanical letters are shown on the packages and the sign below. The mechanical letters on the packages are interestingly composed with other letter forms and were designed by Helmuth Kurtz for A. Durr & Company, A. G., Zurich. The letters formed in metal are on a sign above the entrance to a building in Zurich.

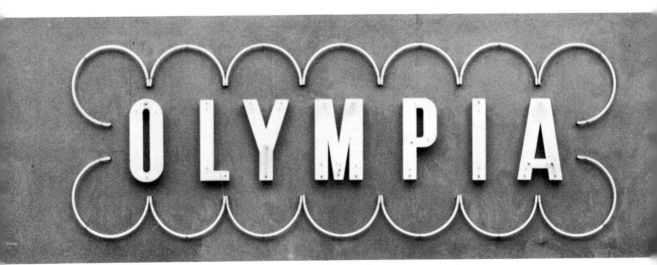

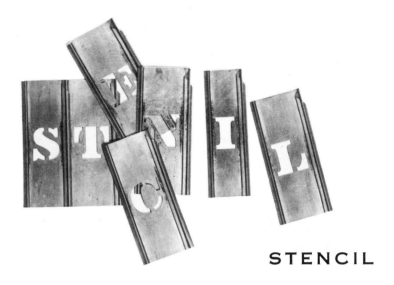

STENCIL

Letters prepared by stencils or designed in the spirit of stenciled letters cannot be considered in a class of their own as, for instance, the Roman letter or the mechanical forms, etc. Almost any fine letter can be developed for stencil usage or effects. Stencil letters have been so much used in the past and their potential for contemporary usage is so great that a small section dealing with them is included as an aid to all letter students. The photograph of stencils above shows the typical brass stencils which may be procured from stores selling office supplies or from stores which make stencils, rubber stamps, badges, and other such items. Obviously the variety of letter styles is limited, and the designer will find that he will have to develop his own forms if he wishes some kind of personal character in his own stencil letters. It is important that the designer not make the mistake of thinking of stencil letters as only a quick method of putting addresses and other information on shipping crates —although this is, of course, an important use. Harassed art teachers who are required to produce several copies of a poster on short notice will find that their students can master and enjoy this work by inspired uses of stencil letters. Professional designers often turn to the use of a letter form based on stencils, either for purposes of reproduction or as a means of suggesting an appropriate atmosphere in relation to a product or service. The designer of the poster on page 53 has captured some of the spirit of shipping and imports by the use of stencil letter forms.

STENCIL

•••

ABCDEFGHI
JKLMNOPQR
STUVWXYZ

'$&c.,

1234567890

•••

ABC123

A complete alphabet of typical stencil letters is shown on the page opposite. The handsome old stencil above is shown by courtesy of S. H. Quint & Sons, Philadelphia. Note that the letters in this stencil are different from those shown in the alphabet in that they are much taller and have a slenderer formation. Letters from an original stencil are usually transferred to another surface by putting paint on the end of a stubby brush and literally "stenciling" through the holes of the stencil. For more professional needs the letters are often drawn with the same care and elegance applied to any other letter form.

£238

Memoir

DINGLE

DONCASTER

LECTURE

160

R

The letters on this page appear in their original version on page 34. The same letters have here been adapted to a stencil appearance and indicate how a great variety of letter forms can be made useful.

Proof that letter style may be varied in a stencil form is exemplified in this poster by Joseph Gering. In this instance the letters were carefully designed rather than actually stenciled.

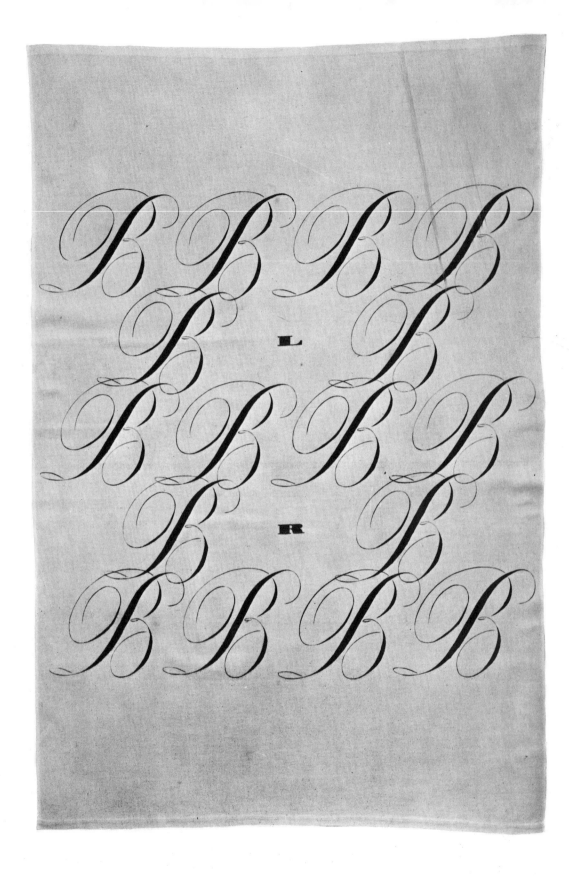

This printed linen cloth was designed by Milton and Reba Weiner, using the initials of the author and his wife; the script B's are printed in black and the L and R in russet on a beige linen. Even script letters are adaptable to stencil technique.

SCRIPT

The script letter eludes efforts to categorize it either in time or in structure. We see its beginnings in the quicker pen motions of scribes, following the Roman period, when the increase in learning called for more and more writing. Its counterpart may be found in Assyrian and Persian letter forms. The Manuals of Arrighi in Italy before 1500 and of Mercator, the great map-maker, about 1540, must be credited for part of the development of the script letter. Later, in the 1600's, Edward Cocker of England and Louis Barbedor of France produced their inspired examples and instructions of writing. The masters of Round Hand during England's great days of commerce and the countless copybooks of penmanship and ornamental writing of our own 1800's (including the well-known instructions of the Spencerian system of business writing) added their bit to the development of these beautiful forms. Today we find our own designers adding to the history of the script letter in the sparkling freedom of brush styles which are primarily a development of our own era. Obviously of all our basic forms, the script letter is bound to rules of construction to the least extent, but it must be pointed out that design tools can provide sound bases for their structure, as shown on pages 62, 63, 64, and 65.

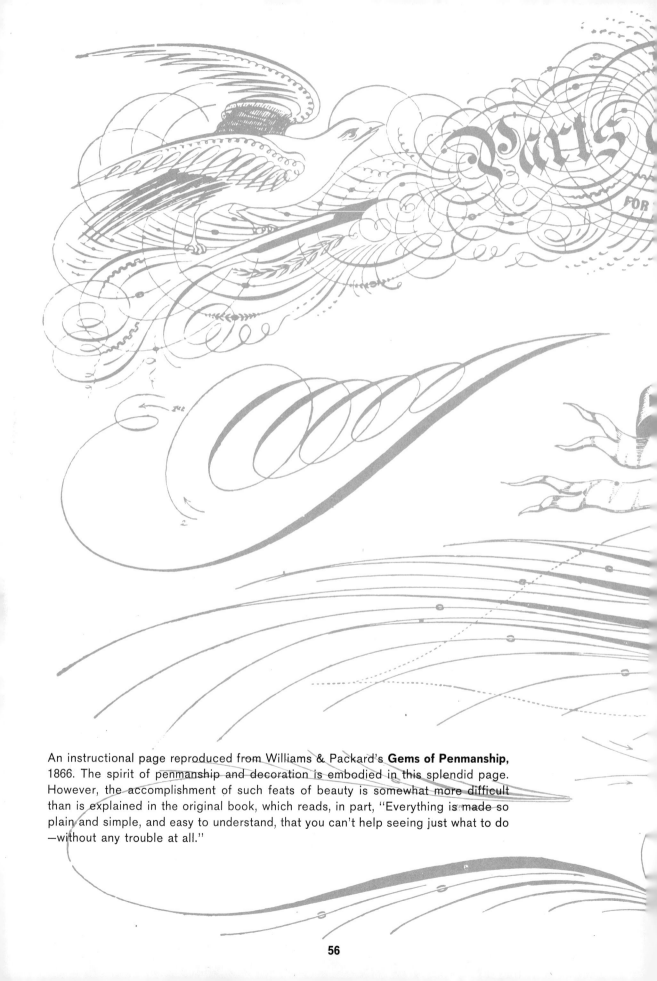

An instructional page reproduced from Williams & Packard's **Gems of Penmanship,** 1866. The spirit of penmanship and decoration is embodied in this splendid page. However, the accomplishment of such feats of beauty is somewhat more difficult than is explained in the original book, which reads, in part, "Everything is made so plain and simple, and easy to understand, that you can't help seeing just what to do —without any trouble at all."

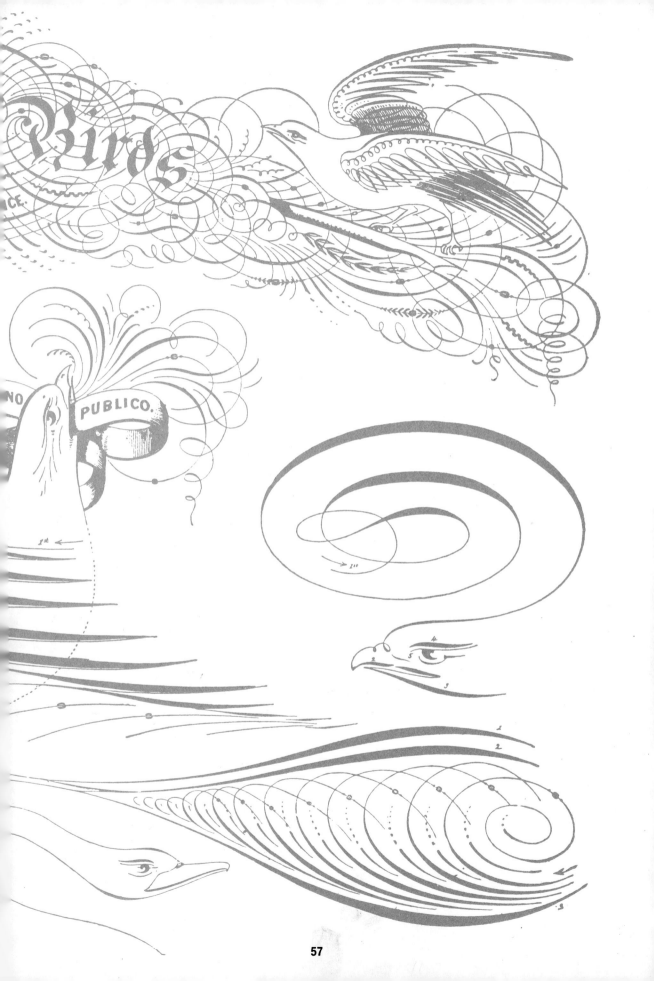

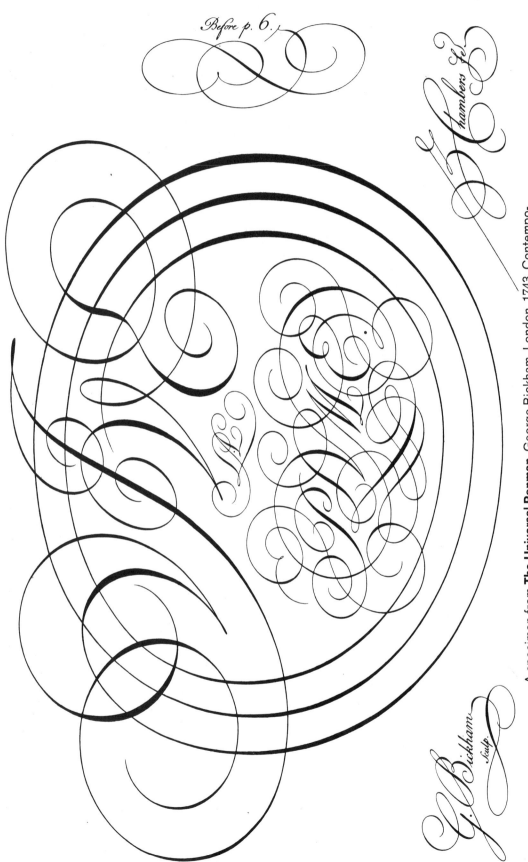

Before p. 6.

Chambers fc.

G. Bickham Sculp.

A specimen from **The Universal Penman**, George Bickham, London, 1743. Contemporary editions of this fine book are available and should be a part of the library of every student of lettering. Courtesy of Paul Struck, New York. On the opposite page is an exceptionally handsome contemporary poster prepared by Mourlot Frères, Paris. The script lettering was designed by Paul Marionnet.

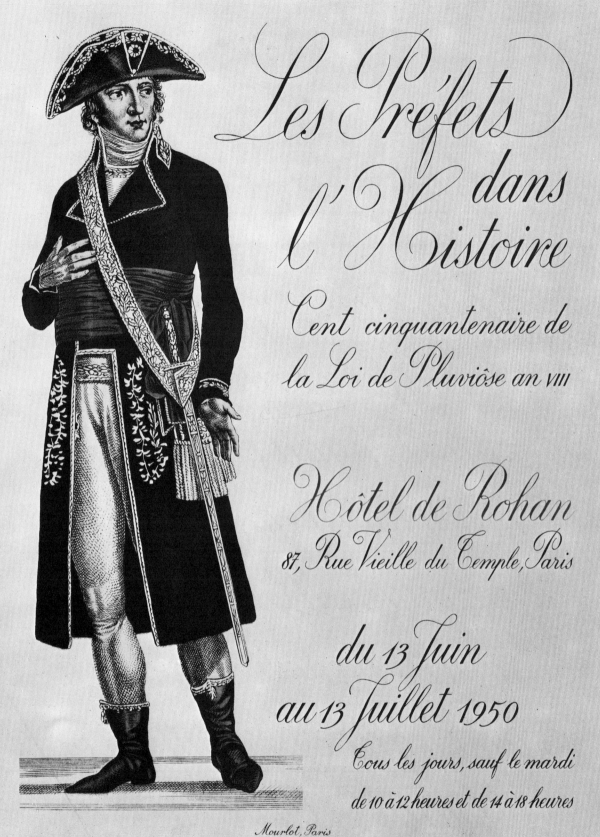

Les Préfets dans l'Histoire

Cent cinquantenaire de la Loi de Pluviôse an VIII

Hôtel de Rohan

87, Rue Vieille du Temple, Paris

du 13 Juin au 13 Juillet 1950

Tous les jours, sauf le mardi de 10 à 12 heures et de 14 à 18 heures

Mourlot, Paris

The Sense of Honour is of so fine and delicate a nature, that it is only to be met with in minds which are naturally noble, or in such as have been cultiva-ted by great Examples or a refin'd Education. 1736.

Script

To the

Writers of the Universal Penman

Gentlemen

*Your most Obliged,
humble Servant,*

London

12 August 1741.

G Bickham

The specimens of script lettering on these pages are also from **The Universal Penman,** by George Bickham, mentioned on page 58, courtesy of Paul Struck, New York. The forms across the tops of these two pages are suggestive of basic strokes for script lettering and ornament. Bickham's letter forms are essentially simple and elegant, and the decorative strokes enrich the whole effect consistent with the letters themselves.

o y f l l u v s k

a b c d e f g h i j k l m

n o p q r s t u v w x y z

1 2 3 4 5 6 7 8 9 0

These pages and the two that follow are prepared as basic instruction for formal script. The letter forms have been made as simple as possible, and construction lines have been properly drawn. The angle of the strokes of these letters is about 55°, and the student is reminded that these angles must be kept consistently the same. Naturally, these angles may be changed to suit the designer and the spirit of his letters. Note that the first line on each of these pages represents the basic stroke structures for all of the letters in the alphabet: those for lower-case letters above and for capital letters on the facing page. It is suggested that the student designer actually place a sheet of tracing paper over these pages and trace the letters in an effort to learn the character of each form. Since these letters are intended as basic forms only, this exercise should in no way interfere with freedom and creative endeavor in more advanced efforts.

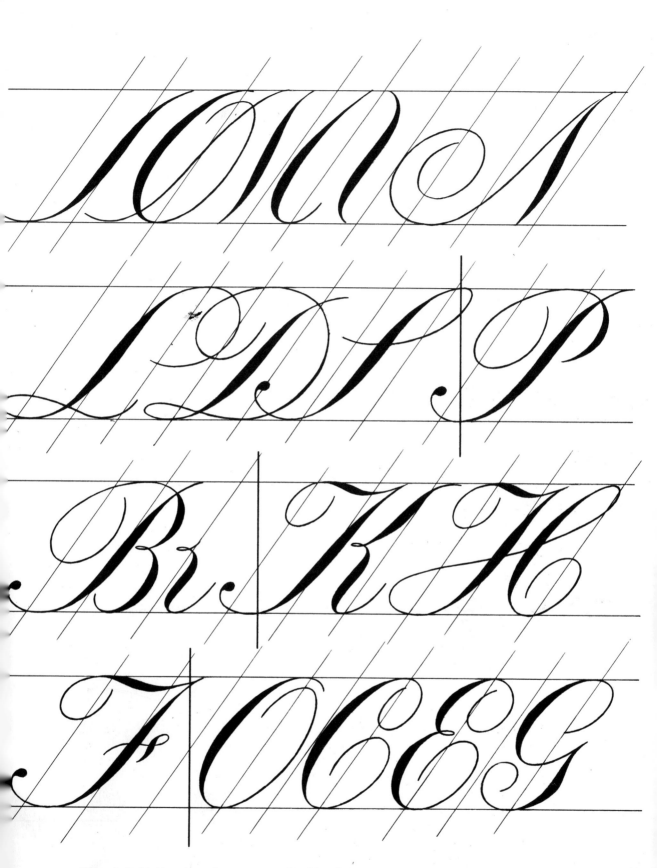

The capital letters have been grouped in "families" to assist the student in his simplification of the capital alphabet. It will be noted that the basic stroke of the letter L is composed largely of the first basic stroke shown here and is also applicable to D

and S. This same stroke is the foundation of the second "family," P, B, and R, and of the third, I, J, K, and H, and T and F. The essential differences in all of these letters are the supplementary strokes forming the remainder of the letter. O, C, E, and G fall, quite obviously, into another group—that of the oval which is the second basic form. The third basic stroke is used in M and N, but in M the fourth basic stroke is required, too. U, V, and W use the fifth basic stroke, while Q, X, and Z use combinations of strokes, including the horizontal stroke. Note that the horizontal guide lines and the lines for the proper angle of the letters are as important in the capital as in the lower-case letters.

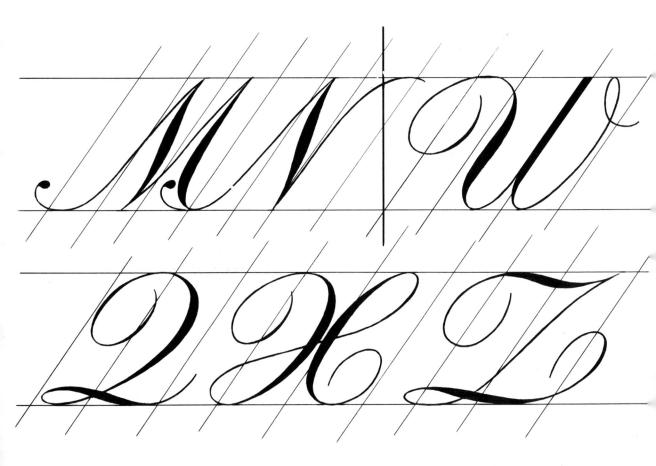

The photographs on the opposite page show the professional method of preparing formal script. Horizontal guide lines and angle lines (generally about 55°) are drawn in pencil on tracing paper. The letters are sketched in in pencil on this tracing paper, and all the details of their character are developed on this or subsequent tracings. When the letters are complete in tracing form they are transferred to illustration or Bristol board for the inking-in process. Most designers prefer to make their final drawing on a good Bristol or illustration board with a very smooth surface, but this is not universal; some prefer a surface with a slight roughness or "tooth." The use of a pen or a brush is a matter of personal preference; outstanding lettering artists differ in this regard. Black drawing ink or lamp black are accepted materials for finishing the letters, and some retouching with white paint (water soluble) may be required. The final result of the project illustrated is shown on page 66.

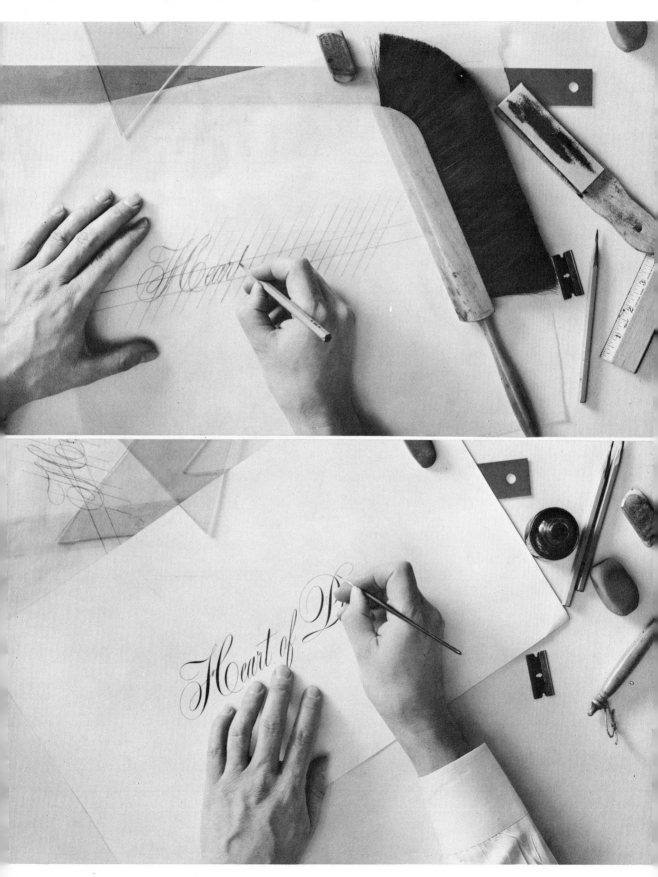

Preparation of the tracing showing proper tools and guide lines drawn in. A medium-hard pencil is required.

The inking process after transfer to illustration or Bristol board. The lettering illustrated is by Arthur P. Williams.

Heart of Paris
1

Second Blooming
2

SEÑOR
Constantino
Ribalaigua
3

The
Belgian Embassy
4

The distinguished examples of script lettering on this page were designed by (1)
Arthur P. Williams, (2) Marley Hodgson, (3) Sam Marsh, and (4) Paul Beers.

(1) Art Director, James Yates. **Holiday** magazine. (2) Art Director, William Fink. **Ladies' Home Journal** magazine.
(3) Art Director, Paul E. Berdanier, Jr. Client, White Owl Cigars. Agency, J. Walter Thompson Company. (4)
Art Director, Suren Ermoyan. **Town & Country** magazine.

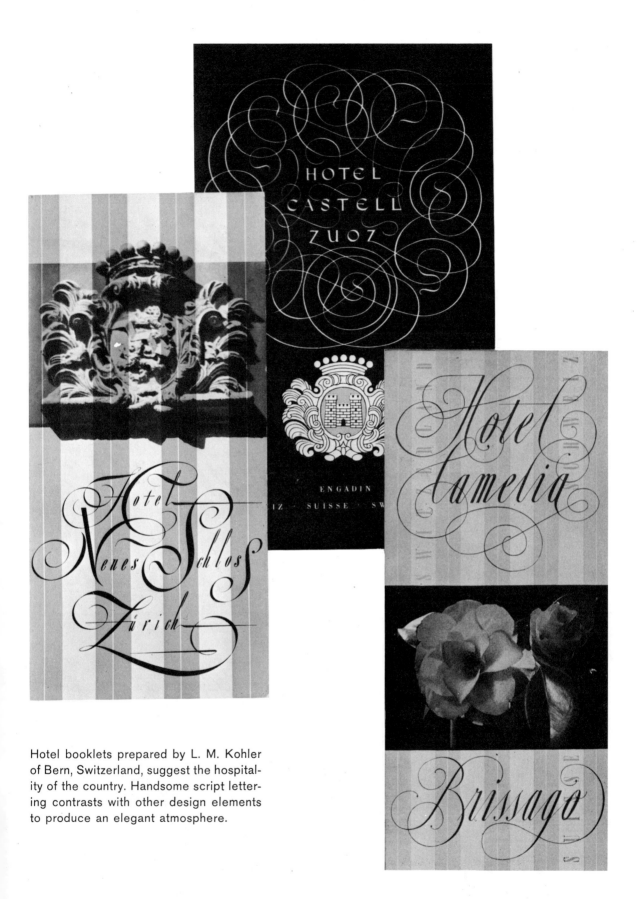

Hotel booklets prepared by L. M. Kohler of Bern, Switzerland, suggest the hospitality of the country. Handsome script lettering contrasts with other design elements to produce an elegant atmosphere.

How many hours ?

Fresh as Paint

Music soft when voices die

Summer Frolic

Garden of the Heart

Wings for Angels

Into the night

Blossom into Spring

Informal or "free" script plays an important part in contemporary lettering. Shown here are several specimens of this approach to lettering art and the tools used to accomplish each. The lettering for these pages was prepared by Arthur Williams.

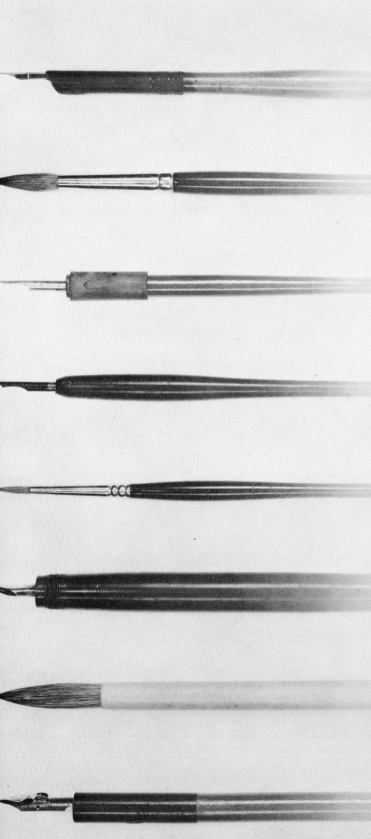

A standard artist's drawing pen was used to create the sprightly example shown here. Many artists use this type of pen for formal script as well.

A zestful example was, in this case, created by a number 5 artist's sable brush. This brush may also be used to create letters having a "wash" effect.

A fine crow quill point pen was used for these sketchily drawn letters. A "whisper" thin line may be achieved only with an extremely fine point.

Another example of lettering in which the use of the fine pen point is obvious. This fast-moving letter is distinguished for its extremes in stroke widths.

The thinner strokes of these letters required a smaller brush than example 2, above. A number 2 or 3 red sable is a good choice in this instance.

A drawing ink fountain pen gives a stroke lacking thick and thin character. A variety of pen thicknesses makes this a versatile tool for this letter style.

A Japanese brush offers the dash of heavy and thin strokes with one tool. Letters prepared in this manner show a delightful spontaneity.

A speedball pen can create letters of artistic merit. A variety of points in both size and design may help the artist to create unusual expressions in free script letters.

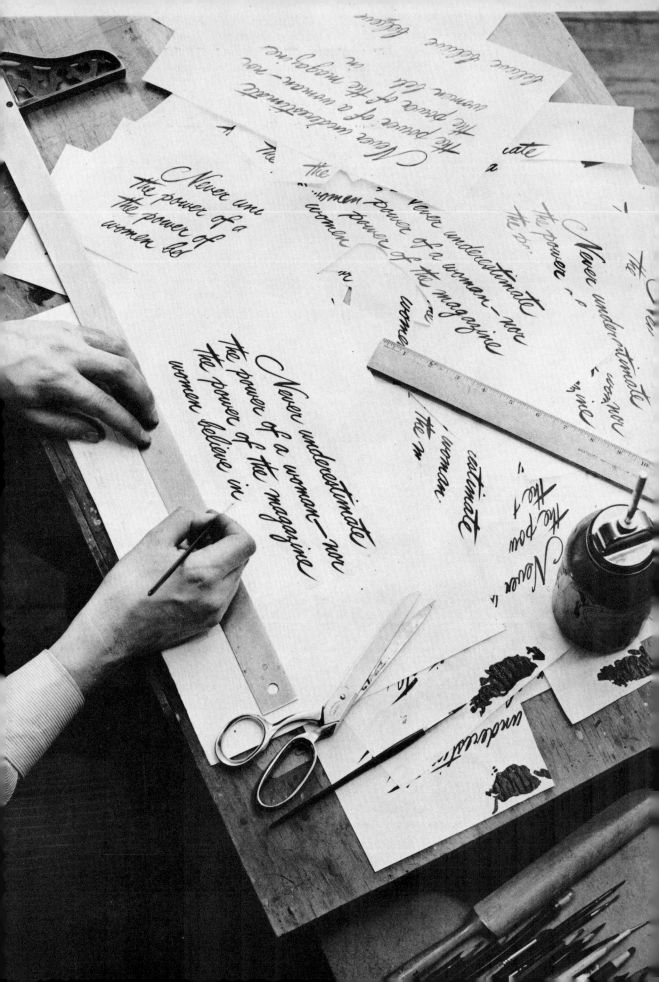

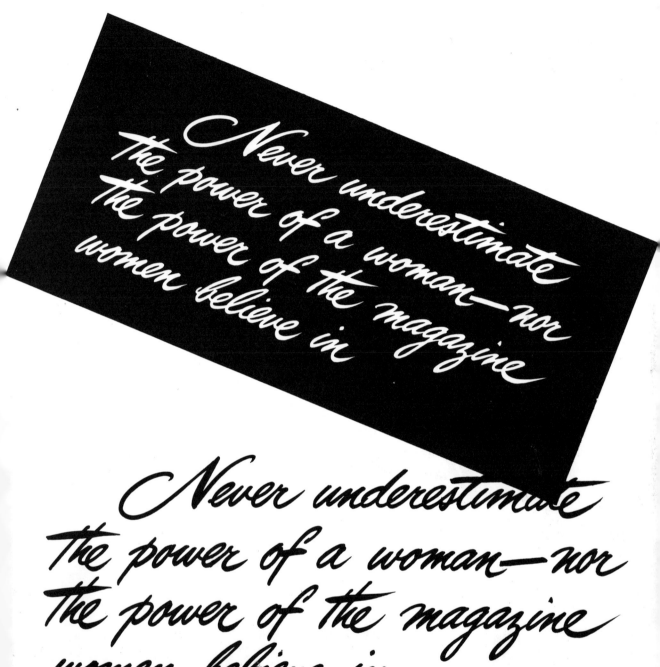

The photograph opposite illustrates a system often used in the preparation of free brush letters. The letters are written, in an experimental manner, time after time on artist's bond paper. When a style satisfying to the artist is achieved, selections are cut from these papers and mounted together to form the finished art. After the mounting is complete, a negative and a positive photostat are procured, as above, and the photostat positive is mounted and presented to the client. The lettering shown here was designed by Marley Hodgson for N. W. Ayer & Son, Inc., Philadelphia. It was prepared for the **Ladies' Home Journal** magazine.

There's a bit of London (1)

Never let him know (2)

Custom Built by Buick (3)

"I dreamt I dwelt in marble halls" (4)

Voilà! (5)

My Brother Bob Taft (6)

The Magic of the French Riviera (7)

Various expressions in informal script lettering prepared by (1) Horace Paul, (2) and (3) Toni Bonagura, (4) Horace Paul, (5) Marley Hodgson, (6) Toni Bonagura, and (7) Sam Marsh.

(1) Art Director, Edith Jaffy. Client, Yardley of London. Agency, N. W. Ayer & Son, Inc. (2) Art Director, Richard Chenault, **American Magazine.** (3) Art Director, Paul Newman. Client, Buick Division of General Motors. Agency, Kudner Agency, Inc. (4) Art Director, Edith Jaffy. Client, Wyandotte Chemicals Corporation. Agency, N. W. Ayer & Son, Inc. (5) Art Director, Paul Darrow. Client, French Line. Agency, N. W. Ayer & Son, Inc. (6) Art Director, Frank Rossi. **American Magazine.** (7) Art Directors, Wallace W. Elton, Richard F. Hurd. Client, Pan American Airlines. Agency J. Walter Thompson Company.

A. M. Cassandre used a single informal script letter to create a
brochure cover with elegant sophistication for Nicolas, France.

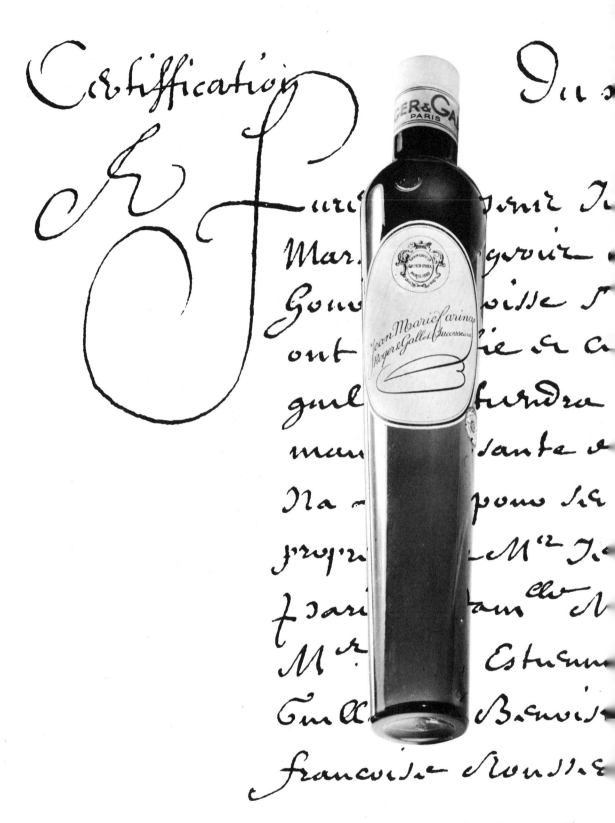

Actual informal handwriting may rightly be considered as a form of free script. The background of these pages is an enlargement of a portion of a letter written by Jean Baptiste Poquelin Molière in 1664 and now in the British Museum. The label above and the package at right attest to the appropriateness of handwriting used as lettering. The label is courtesy of Roger and Gallet, Paris; the package was designed by Madame Elsa Schiaparelli of Paris.

SOMETHING NEW AND FRESH!!
SPRING & SUMMER
GOODS

LOUTHER & NEEL

Are now receiving from the Eastern Cities, a new and handsome assortment of Spring and Summer Goods, consisting in part of

British, French and American
DRY GOODS

HARDWARE AND CUTLERY,
LADIES' SLIPPERS, STRAW & LEGHORN BONNETS,
STRAW AND LEGHORN HATS,
Groceries, Nails, Spun Cotton &c. &c.
AN ASSORTMENT OF TINWARE,

And many other articles, which they deem it superfluous to enumerate, suffice it to say their stock will be found as general as any in this section of the country.

☞ Call and see, as they feel confident that Prices will insure Sales.

All kinds of COUNTRY PRODUCE taken in Exchange for GOODS.

Laughlinstown, April, 1846.

Young, Printer, Black Horse Alley, Philadelphia.

A merchant's posting printed in the romantic style of 1846. These and theatrical postings are excellent sources of inspiration for design and lettering.

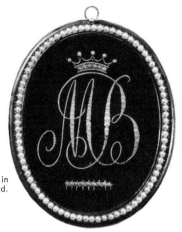

Letters in small pearls on the back of a miniature in the fine collection of A. J. Fink, Baltimore, Maryland.

ROMANTIC

The letters presented in this section cannot be approached in the same manner as the forms in the Classic, Mechanical, and Script sections. Their structures, however, embody the principles of other fine letters and, often, a combination of several forms. These are the letters of "romance." They come from theatre handbills, from old type faces, from fine old music sheets, and from the inspired imagination of lettering artists of many an era. They breathe the spirit of the waltz, of crinoline and lace, of holidays at Grandma's house, and of an anniversary. Romantic letters cannot be by-passed as something old-fashioned. Their constant revival attests to their virility, and contemporary designers find many uses for these letters and for the characteristic designs and arrangements in which they have been used. The interested student will enjoy many hours of pleasure in seeking for examples of letters in this category in old bookstores, antique shops, type shops, and other similar places. He will thus be adding to his own storehouse of inspiration and information.

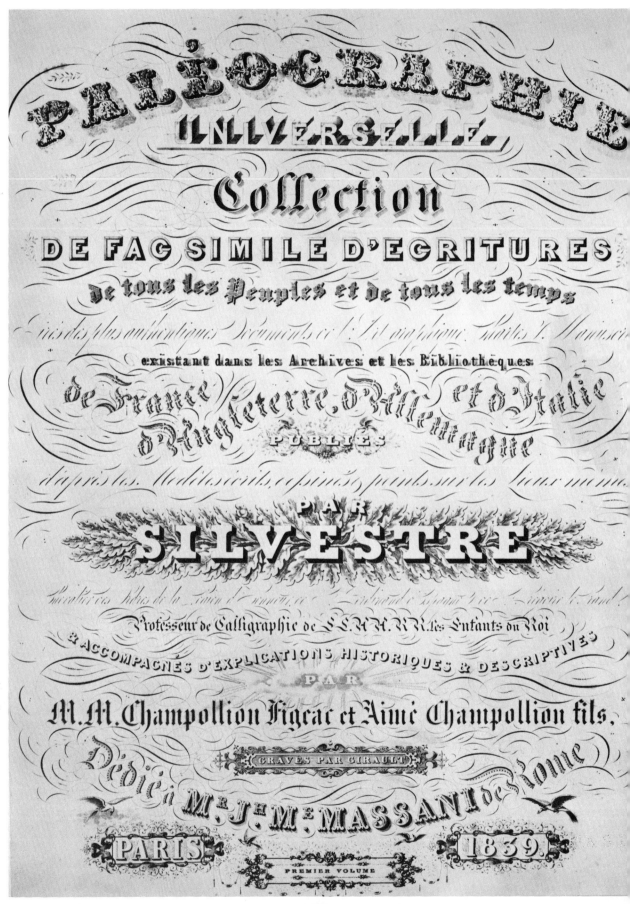

PALÉOGRAPHIE

UNIVERSELLE

Collection

DE FAC SIMILE D'ECRITURES

de tous les Peuples et de tous les temps

tirés des plus authentiques Documents de l'Art graphique, Chartes et Manuscrits

existant dans les Archives et les Bibliothèques

de France, d'Angleterre, d'Allemagne et d'Italie

PUBLIÉS

d'après les Modèles écrits, copiés, peints sur les lieux mêmes

PAR

SILVESTRE

Professeur de Calligraphie de S.S.A.A.R.R. N.N. Les Enfants du Roi

& ACCOMPAGNÉS D'EXPLICATIONS HISTORIQUES & DESCRIPTIVES

PAR

M.M. Champollion Figeac et Aimé Champollion fils,

GRAVÉS PAR GIRAULT

Dédié à M.r J.h M.e MASSANI de Rome

PARIS — 1839.

PREMIER VOLUME

The title page from a book of decorative and romantic letters by J. B. Silvestre, engraved by Girault, Paris, 1839, is shown on the opposite page. The letter "R" above is greatly enlarged from the word **Paléographie.** Courtesy of the Library, Philadelphia College of Art.

LIGHT STREAK
BENDER GARDEN
SERENE RIGHT
SABLES SITE
SUN LEGGER
KITE STIR

The fine examples of type faces of the romantic period above are reproduced from a type specimen book of MacKeller, Smith & Jordan, Philadelphia, 1871. The contemporary examples of romantic letters from **Town & Country** magazine were designed by Paul Beers, 1949. Art Director: Suren Ermoyan.

SPRING

DIVINATION

A folio of fashions of the future

The Rustle of

SPRING

INCIDENT

SPRING

COATINGS

MISTIFIED

GENDER

METEOR

UNION

AND LIBERTY

REFULGENT

EXCHANGE

GLIMMERED

GARLANDS

EAVESDROP

BUDDING BLOSSOMS

SOLID BLOCK

ONE AND INSEPARABLE.

L. JOHNSON & Co

Romantic letters from a type specimen book of the 1800's of L. Johnson & Company, Philadelphia. The eagle is an enlargement of a typical type ornament of the period. Courtesy of the Stephen Moylan Press, Whitford, Pennsylvania.

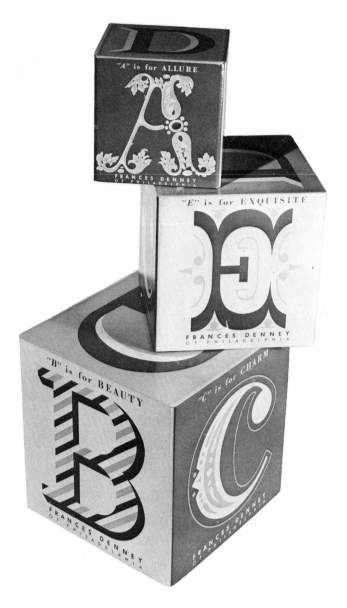

A fine application of romantic letters in packages for beauty products. This set of "beauty building blocks" was designed by Elizabeth Chambers Wynkoop for Frances Denney of Philadelphia. The romantic letters below were designed by Fletcher MacNeill.

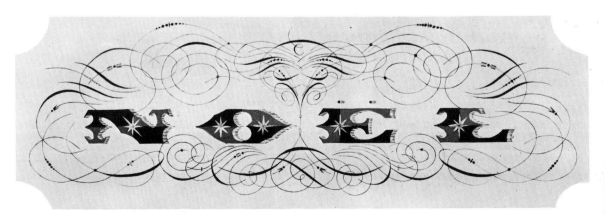

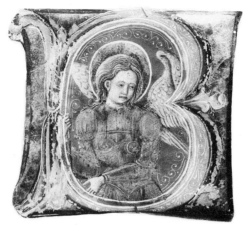

INITIALS

The elegant initial letter "B" with St. Michael the Archangel serves to introduce a small section of this book devoted to initial letters, old and contemporary. This manuscript letter is designed in tempera and gold leaf on parchment; it is French, about 1400. Unfortunately the initial letter has often been considered only as a design for manuscripts or as a crutch for typographers in efforts to enliven compositions. It is, therefore, pleasurable to observe examples in which the designer or typographer has used imagination to achieve exciting results. In using the letter as an initial or illustrative design, it may be combined wth decorative figures, architectural motifs, flowers, and other objects. It should be observed that the character and structure of a letter are as important in an initial letter as in any other form; discrimination and taste are most necessary to prevent the initial form from becoming forced and absurd. The initial and illustrative letters on the following pages are unique achievements in the realm of lettering art.

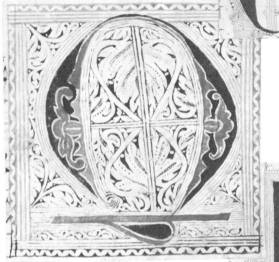

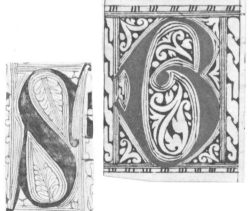

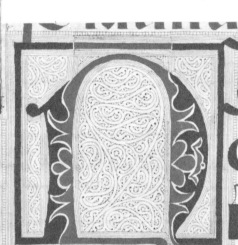

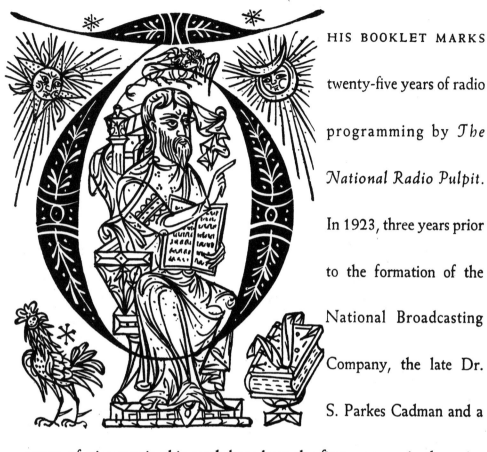

HIS BOOKLET MARKS twenty-five years of radio programming by *The National Radio Pulpit.* In 1923, three years prior to the formation of the National Broadcasting Company, the late Dr. S. Parkes Cadman and a group of pioneers in this work broadcast the first program in the series over the New York station WEAF, now WNBC. + + They realized that through the new medium of radio, thousands who would not ordinarily attend church services could be reached. From the beginning, they recognized that religious radio should complement and increase interest

A page from a contemporary advertising booklet designed for the National Broadcasting Company by Joseph Low. Art Director, Allen F. Hurlburt. The letter form in this design is essentially the same as those on the page to the left, which are initial letters from old pages of music. Courtesy of Edward Warwick.

This piece is a reproduction of a plate lithographed in Strasbourg and designed by Midolle, undated. It suggests possible application of a very ornate initial letter.

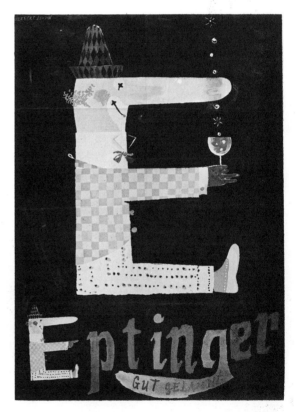

Four examples of initial letters are shown on this page. The first was created by drawing a letter on an old print. The letter at the right, top, is from an alphabet known as Forestière from **Paléographie** by Silvestre, 1839. Draeger-Frères, Paris, used the handsome initial D in a book advertising their fine printing processes. The humorous and happy use of a single letter on a Swiss poster design by Herbert Leupin was produced by Wolfberg, Zurich.

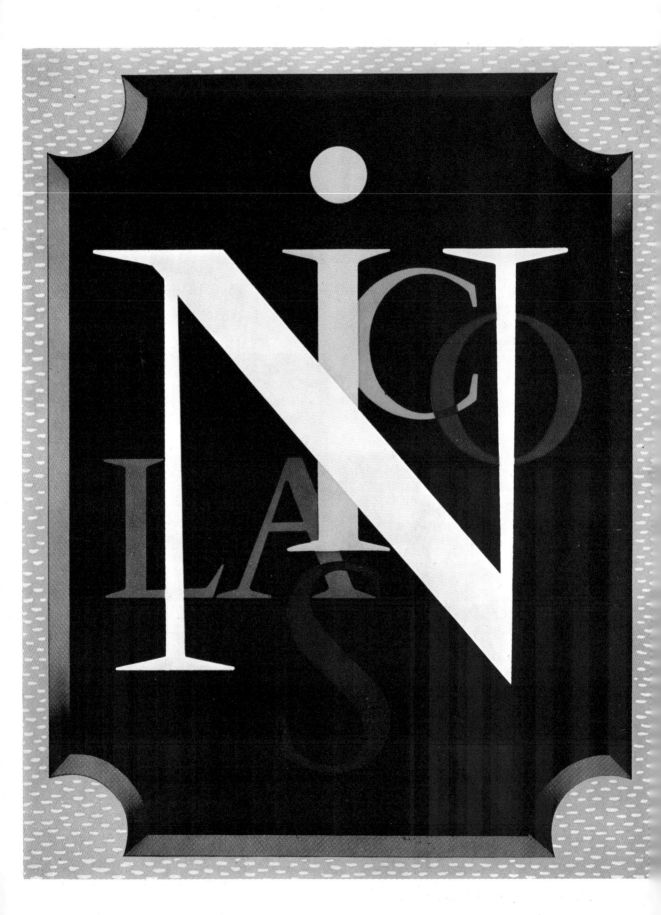

As evidenced in the initial letter, the purpose of a letter form can go beyond that of simple legibility. At the top of this page is shown an example of an experimental composition with letters designed by Milton Fisher. Letters with pictorial implication were designed by Lemuel B. Line for an advertisement for Felt & Tarrant Manufacturing Company. Agency, N. W. Ayer & Son, Inc., Philadelphia. Art Director, Leon Karp. On the opposite page the elegance of letters to the glory of wine is evidenced in a brochure cover by A. M. Cassandre. Courtesy of Nicolas, France.

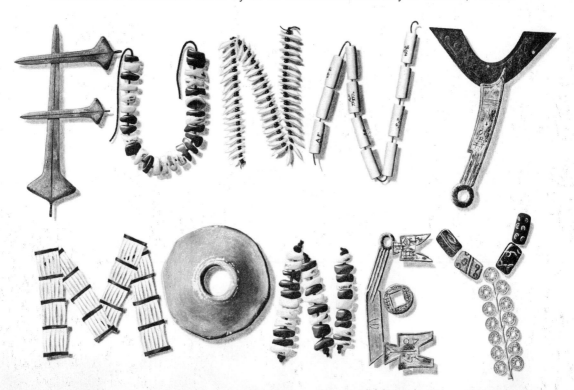

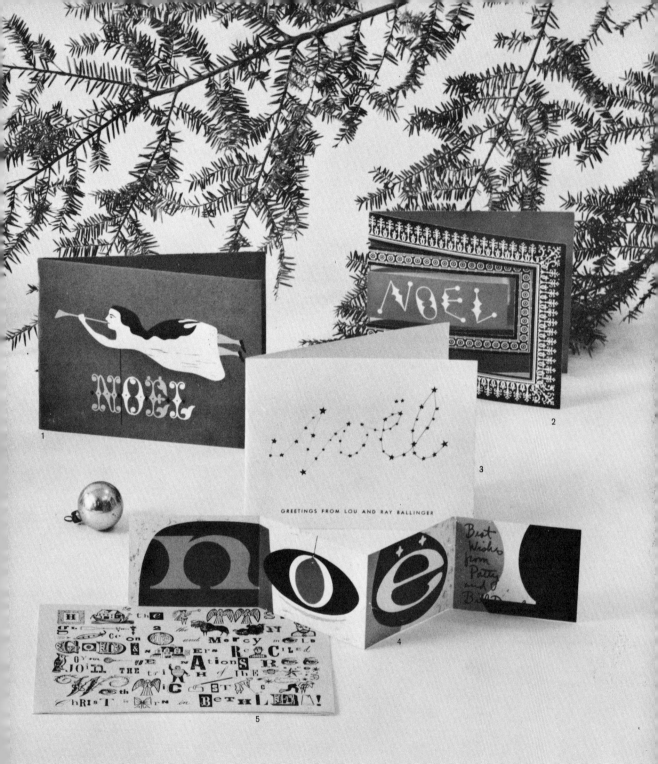

Bold romantic letters form the design motif in drapery material designed by Tammis Keefe for Goodall Fabrics (see opposite page). The Christmas cards shown on this page indicate how the simple message of Christmas may be expressed by designs almost wholly dependent upon interesting lettering. The designs are by (1) Arthur P. Williams, (2) Karl Koehler, (3) Raymond A. Ballinger, (4) William Dressler, and (5) Jack Weaver.

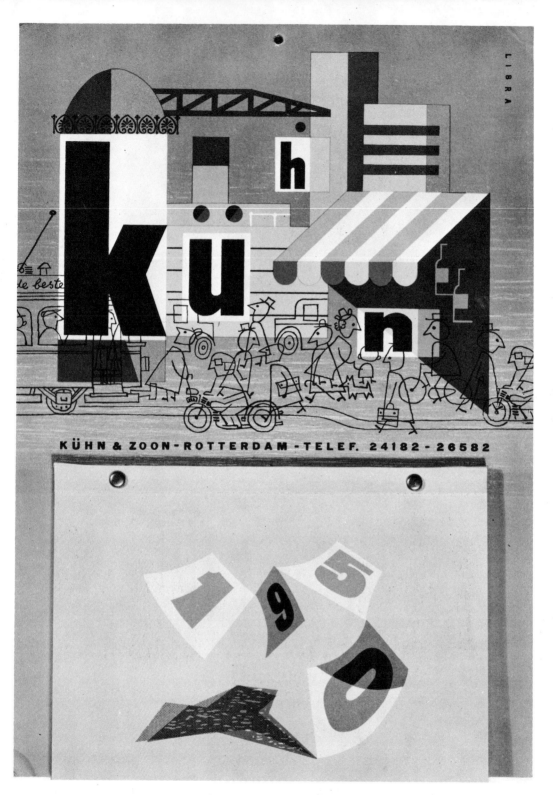

Even though it is several years old, this calendar is still interesting because of its sprightly organization of design and letter forms. Designed by Libra Studio, The Hague, for Kuhn & Zoon, Rotterdam, Holland. The two items on the opposite page show the use of letters in designs for display purposes. The car card and poster was designed by Raymond A. Ballinger for the Philadelphia Saving Fund Society, Philadelphia. Art Director, Guy Fry. Agency, Gray & Rogers. Letters molded in metal or plastic were used in the convention display designed for A. Michaud Company, Philadelphia, by Henry P. and Libbie Lovett Stewart.

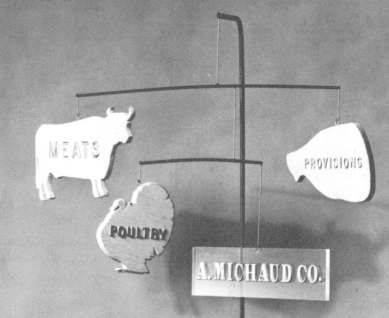

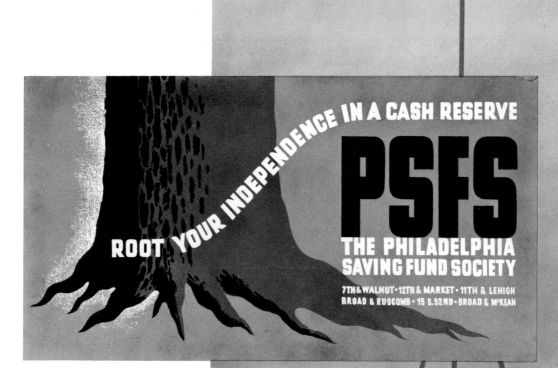

It is hoped that the study of this book may be but the beginning of the reader's quest for more knowledge of letter forms as they apply to all design fields. For further information this short but important list of books related to lettering may be found helpful to both the student and the professional designer.

THE ALPHABET, Frederic W. Goudy, 1918, New York: Kennerley

> A fine book on the history of letters by a master of letter and type design.

ELEMENTS OF LETTERING, Frederic W. Goudy, 1926, New York: Kennerley

> Practically a companion piece to the book above by the same distinguished author.

THE ANATOMY OF LETTERING, Warren Chappell, 1935, New York: Loring & Mussey

> An interesting and concise book, as the name implies, on the anatomy of our letters.

THE 26 LETTERS, Oscar Ogg, 1948, New York: Crowell

> An exciting and thorough book on the history of our letters.

THE HISTORY AND TECHNIQUE OF LETTERING, Alexander Nesbitt, 1957, New York: Dover Publications, Inc.

> An inexpensive, paper-bound volume with extremely interesting and knowledgeable text on the history of letters.

LETTERING FOR ADVERTISING, Mortimer Leach, 1956, New York: Reinhold

> A fine book on the tools and techniques of lettering by a distinguished teacher and craftsman.

LETTERING (SCHRIFTEN, ECRITURES), Walter Kach, 1949, Switzerland

> An excellent book by a Swiss teacher and graphic artist produced in a most beautiful format.

THE DEVELOPMENT OF WRITING (Die Schriftentwicklung), 1959, Hs. Ed. Meyer, Zurich: Graphis Press

> A small but beautiful paper-bound book on the history of writing and letter forms.

THE SCRIPT LETTER, Tommy Thompson, 1939, London: The Studio

> A fine book on the form, construction, and application of script letters by an outstanding lettering artist.

THE UNIVERSAL PENMAN, George Bickham, 1941, New York: Struck

> A compendium of penmanship, flourishes and calligraphic illustrations by a master penman and engraver of 1700.

BECKER'S ORNAMENTAL PENMANSHIP, George J. Becker, 1941, New York: Zucker

> A rare book of ornamental penmanship first printed in 1854 and reprinted from the original plates in 1941.

LES ECRITURES FINANCIERE ET ITALIENNE-BASTARDE, Louis Barbados, Paris Les Editions Holbein, Basel, Switzerland

> Another important and historical book on script forms.

TYPOGRAPHIE, W. Bangerter-W. Marti, 1948, Luzerne

> For the student who wishes to extend his interest in letters into the field of typography, this book produced in Switzerland shows inspired examples.

TYPOGRAPHY, Ben Rosen, 1963, New York: Reinhold

> As stated by the title, this book is about typography, but it is of great importance to the lettering and graphic artist.

LETTERING FOR ARCHITECTS AND DESIGNERS, Milner Gray-Ronald Armstrong, 1962, London: B. T. Batsford, Ltd.

> A handsome and interesting book dealing with the use of letters and symbols in architecture, business, and the public scene.